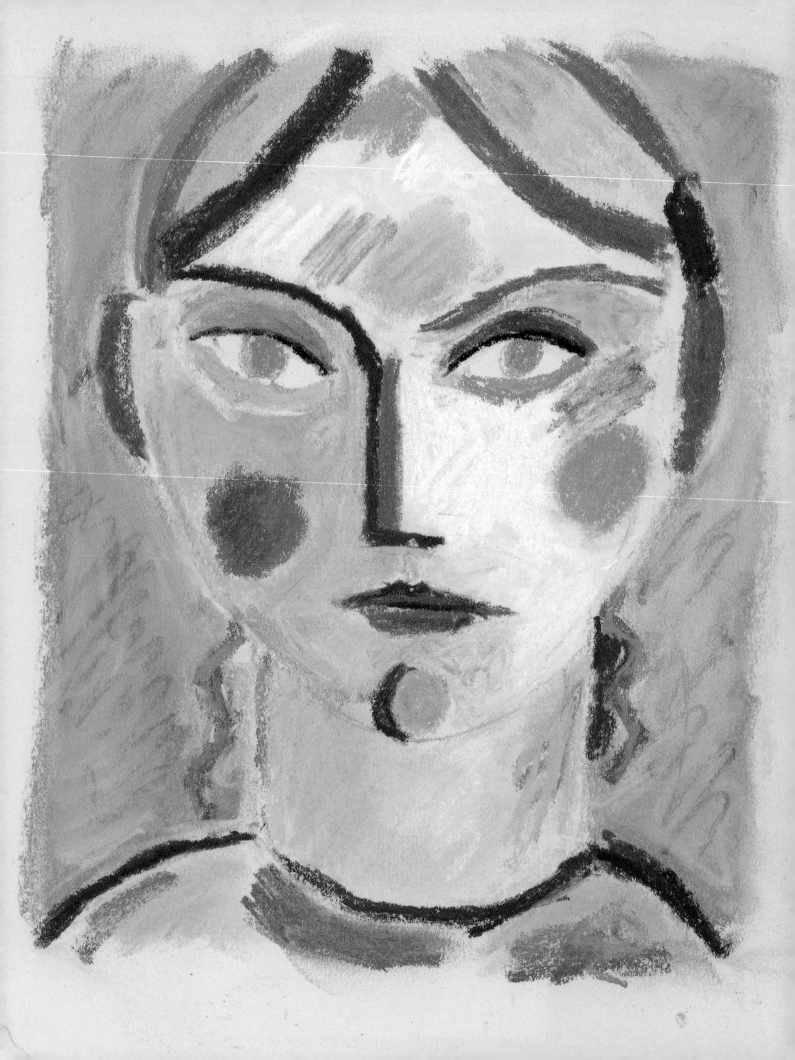

Creative
DRAWING

A practical guide to using pencil, crayon, pastel, ink and watercolour

Barrington Barber

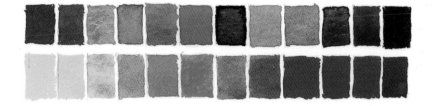

ARCTURUS

ARCTURUS

This edition published in 2013 by Arcturus Publishing Limited
26/27 Bickels Yard, 151–153 Bermondsey Street,
London SE1 3HA

ISBN: 978-1-78212-223-4
AD003636EN

Printed in Singapore

Contents

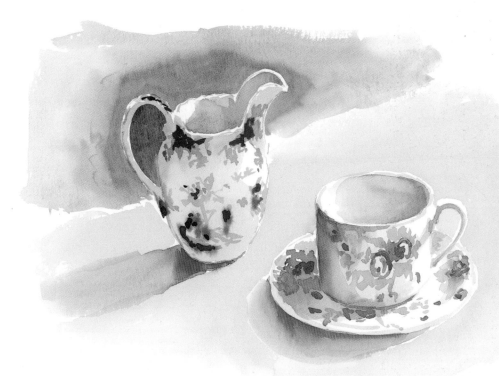

Introduction

While drawing is sometimes thought of only in terms of monochrome pencil, pen and charcoal, artists often draw in colour too. In this book I examine methods of drawing in various colour mediums, showing examples of coloured pencil, pastel, crayon, coloured inks and watercolour and explaining how to work with them yourself.

It is very easy to become confused by the many techniques of introducing colour into the already complex area of drawing in tone, line and texture. I believe the solution is to approach it as though learning to draw afresh. Understanding colour is quite a complex affair, and the book assumes that readers will benefit from an introduction to the basics of colour theory. This need not delay you, however, because even if you do not wholly grasp it at once, the simple practice of applying colour in your drawings will provide you with valuable experience, leading you to work out tonal values to your own satisfaction. And please don't believe that there is only one correct way; try out every variation that occurs to you while working, and you may discover yet more interesting ways of manipulating colour schemes.

I have set as many exercises in the use of colour as seemed practical, and have tried to include all the really essential methods. You will find it useful to look at the work of other artists, both living and dead, and to observe how they worked out the chromatic schemes in their own pictures. Some are exponents of very subtle and restrained values, while others are far more vibrant or strident in the way they use their pigments. The key always seems to come down to two things: first, harmony; and second, contrast. Of course, all artists have used both at some time in their careers, but they often have a tendency to favour one or the other. In this book I have tried to show the effects of both approaches.

The addition of colour to your drawing can increase the enjoyment both to yourself in creating it and, afterwards, to your viewers. The power of colour to enhance a subject is most evident when you compare a black and white reproduction of a painting with the same picture in colour. Not only that, the natural symbolism of colour, or at least the type of symbolism that we attach to the colour of an object, brings further meaning to the subject matter.

The different mediums that you experiment with should add further to your enjoyment. Don't worry if at first you might make rather a mess of the exercises; no one ever became any good at art without making lots of mistakes to start with. As long as you consider carefully everything you've done, no matter how unsatisfactory or disappointing it might be, you will soon learn not to repeat your mistakes too many times. Experimentation is the way that art evolves; it is not just the preserve of scientists. So, prepare to have a good – if occasionally difficult – time with the exercises in this book, with my heartfelt good wishes on the expansion of your artistic ability.

Barrington Barber

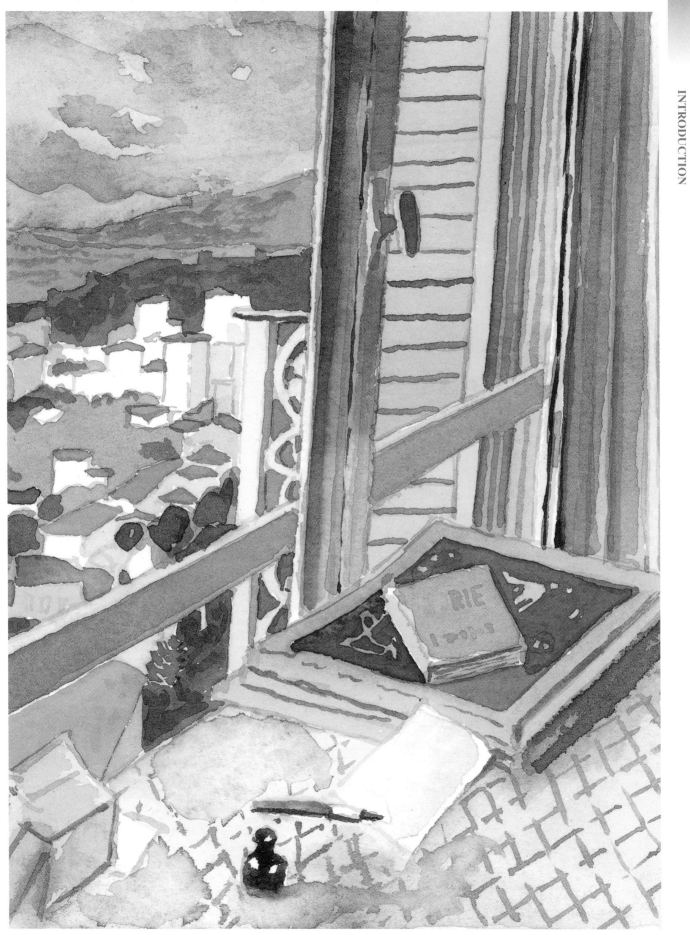

Getting started

There are various methods and mediums to explore for drawing in colour, so this chapter begins with the materials and how to develop skills in using them through following a series of exercises. We shall be concerned mostly with drawing in coloured pencil, pastels, coloured inks and watercolour. You may not want to use them all but it is a good idea to try them out, even if only in a limited way, so that your choice of which medium to use will be based on knowledge and experience rather than mere guesswork.

Go through all the exercises shown here because they will familiarize you with a range of mediums and also provide you with practice, which every artist needs to ensure that they have some control over their medium. You may even find you can invent a few exercises of your own, which is a sign that you are engaging with the medium in depth. It is also more fun for you when you play around with different mediums. Most of the exercises are simple enough, but don't be misled into thinking that therefore they are not worth trying out. In fact, simple repetition of straightforward technical practices is the bedrock of all artistic expertise. When you see a young artist doodling with patterns and repetitive marks on a sheet of paper, he or she is in the process of learning the manual dexterity that is so important for any artist.

Drawing is always drawing, whether in colour or not, so do not be put off if you know nothing or little about it. The way to learn is by experimentation and experiencing both success and failure. When you are drawing easily without any problems, it is only because you have previously overcome difficulties of some sort. And remember, when you appear to be having difficulties, that is when you are learning most. Perseverance really will pay.

Materials and mediums

Here is a selection of the materials required for drawing in colour. I have chosen those most easily obtained from art or stationery shops. As an artist you will always want to use the best, but occasionally less specialized materials can be just as good.

1. Coloured pencils Don't concern yourself too much with the brand, although some are better than others. Go for as many variations in colour as you can find. Thinner pencils can be of superior quality but not always. Try them out and make your own judgement. **Watercolour crayons** are similar to ordinary coloured pencils but you can use a brush with water to spread their colour over larger areas. There are several brands available.

2. Fineline graphic pens These pens are good for drawing and behave similarly to a coloured pencil but have a more intense colour value.

3. Brushes The best are sable but there are many varieties of hair and synthetic fibre. You will only need two or three brushes, especially if they come to a fine point. A size 0, one 3 and perhaps one 7 or 8 would be sufficient. For extending pastels you might need a hog hair or some other stiff brush.

4. Soft pastels These tend to be expensive to buy and get used up quickly, but for some work they are essential. They come in a wide range of colours.

5. Hard pastels Also known as conté crayons, these are essentially the same material as the soft ones but bound together in a compressed form. Hard pastels are square in section whereas the soft ones are round. The range of colours is again enormous, they last longer and are easier to manipulate.

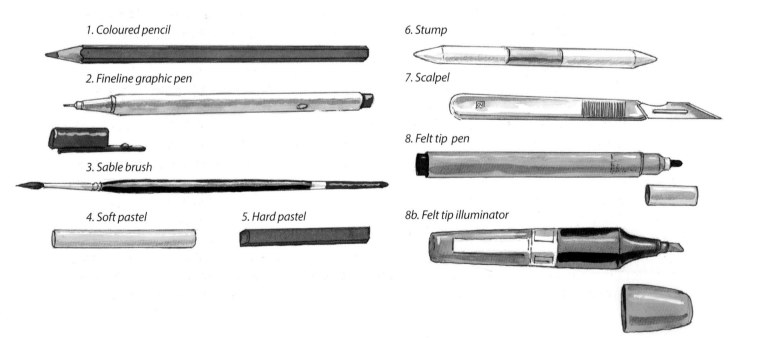

1. Coloured pencil

2. Fineline graphic pen

3. Sable brush

4. Soft pastel

5. Hard pastel

6. Stump

7. Scalpel

8. Felt tip pen

8b. Felt tip illuminator

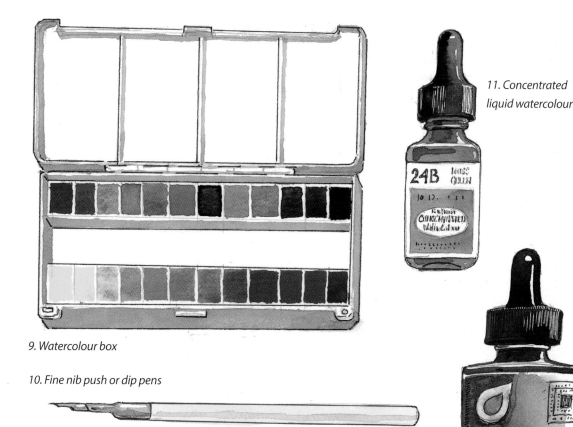

9. Watercolour box

10. Fine nib push or dip pens

11. Concentrated liquid watercolour

12. Indian ink

6. Stumps These are just rolls of paper in a compressed form, pointed at both ends. They are very useful for extending the tones of your pastels. They come in several sizes, but usually you will only want two, a large fat one and a thin one.

7. Scalpel While they are the best tool for sharpening pencils, crayons, pastels and so forth, scalpels are extremely sharp and so are not advisable for students under 16 years. A craft knife is almost as good and safer to use.

8. Felt tip pens and illuminators These pens allow thicker, more solid areas of colour to be put on quickly and are useful for larger drawings.

9. Watercolour box Watercolours are easiest to use from a box, but they can be bought in small tubes as well.

10. Fine nib push or dip pens These provide variable line and pen strokes, from very fine to fairly thick depending on the pressure applied. Some nibs are more flexible than others.

11. Concentrated liquid watercolour These colours are just like ink in consistency but may be diluted with water. They can be applied with a pen or a brush.

12. Indian ink A more permanent ink, this is available in many colours. It is perfect for pen work but can be used with a brush.

Paper:

Watercolour paper Ideal for anything where water is the main diluent, it takes the colour well and helps to stop it going patchy.

Ingres paper This is very good for pastel drawing and it comes in many shades. You will find it easier to draw in pastel on toned paper because white paper gives a rather too stark contrast.

Cartridge paper Available in various weights and surfaces, cartridge paper is inexpensive and versatile. Experiment with different types to suit your piece of work. A smooth surface is generally good for pen and ink and rough is better for pencil work.

Holding the tools

The way you hold your pen, brush, chalk or pencil doesn't always have to be the same as how you would hold a fountain pen. Sometimes you get better, freer results by holding them as you would a stick or a house-painting brush. The only one that you will have to hold the same way as a fountain pen is the dip pen with ink because it is very difficult to manipulate any other way. We show here the variety of ways to hold your drawing tools. You may need to practise these before you become comfortable with them.

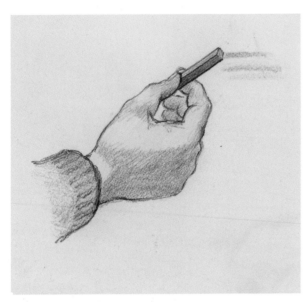

1. Hold the pastel loosely

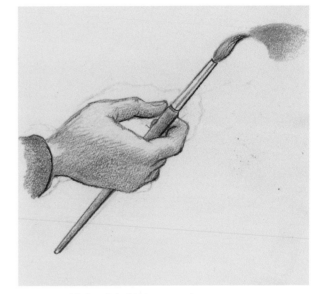

3. Large sable brush held like a wand

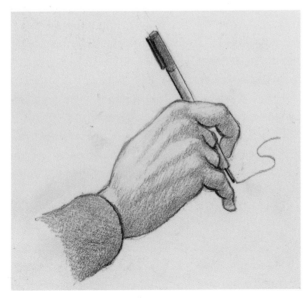

2. Fineline pen held conventionally but with your little finger supporting it

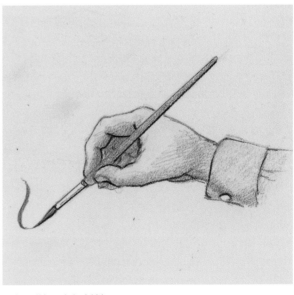

4. Small brush held like a pen

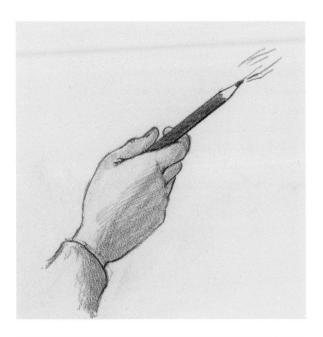

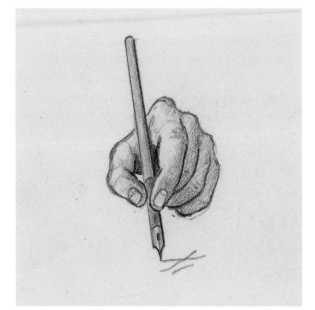

7. Push or dip pen held normally

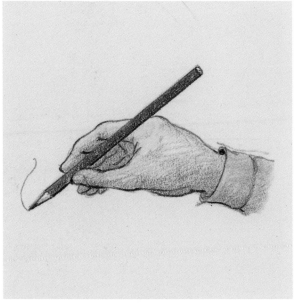

5 and 6. Pencil can be held either like a wand or more conventionally

Masterstrokes

A pen line doesn't have to be firm and precise any more than a pencil line or a pastel stroke must be – in fact a rather wobbly and meandering pen line often looks more convincing than a smooth, hard-edged line. The main thing in holding an implement for drawing is not to grip it too tightly. Your grip should be as light as is possible without losing control of the tool.

Drawing positions

In order to draw well, make sure that you are comfortably positioned – try different positions to find the one most suited to you. It is nearly always best to have your drawing supported on a sloping board. This is particularly useful when using watercolours because it allows the water to run down the paper and makes it easier to control the intensity of your colour, but a sloping surface is just as useful when using chalk, pastel, pencil or pen. For most drawing, except with pen and ink, I prefer to stand up using an easel, but sometimes it is not convenient, nor does it always give the best results. When working with pen and ink, you should keep your paper surface less upright, otherwise the ink does not flow properly to the nib, and the same is true to a certain extent with brushwork in watercolour. But having the paper absolutely flat is not a good idea because you tend to view it too much from one angle, which can give rise to distortion.

1. Standing at an easel

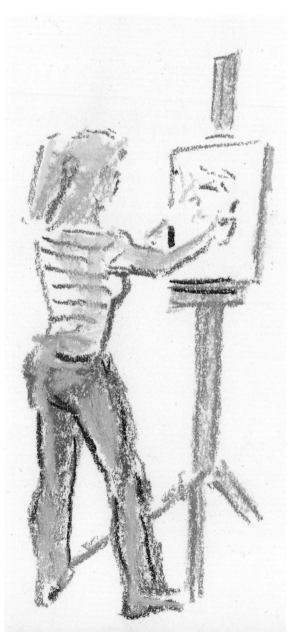

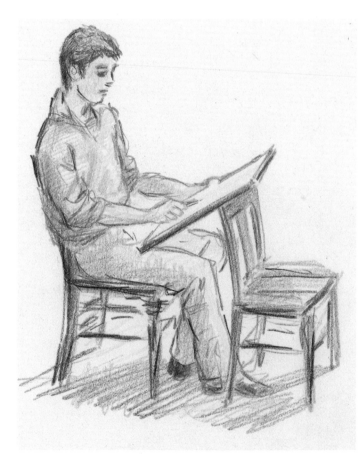

2. Sitting down with the board supported by the back of another chair

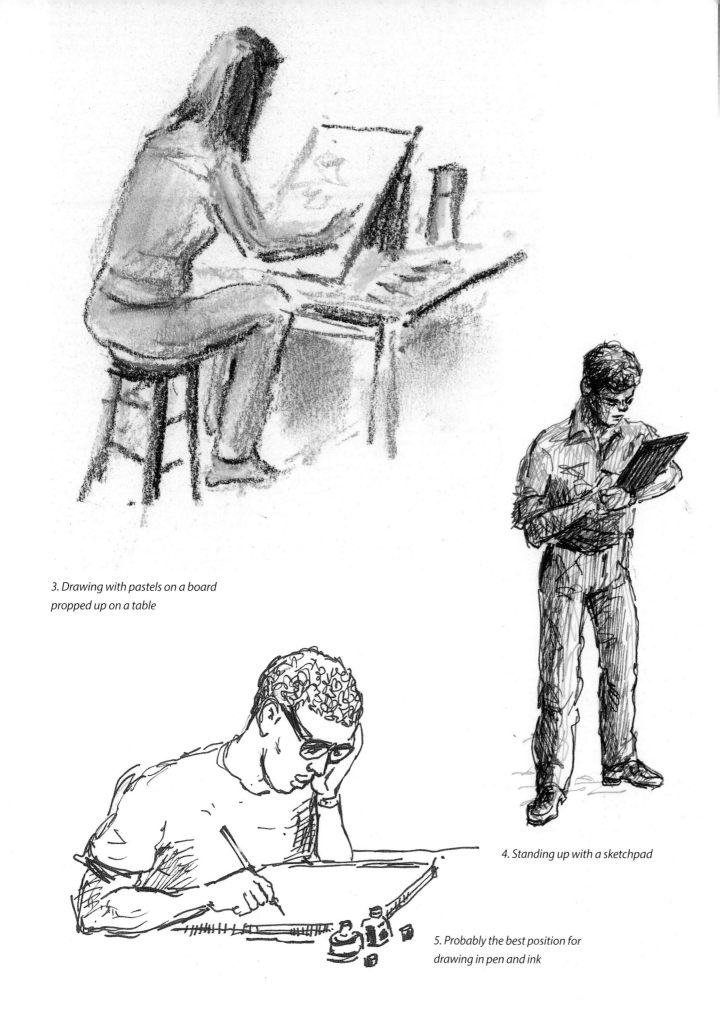

3. Drawing with pastels on a board
propped up on a table

4. Standing up with a sketchpad

5. Probably the best position for
drawing in pen and ink

The colour wheel
Colour control

This simple device is very useful for demonstrating the relationships between the different colours of the spectrum and holds true for any of the mediums that you will be using.

The diagram shows an inner circle of colour containing the three primaries, red, yellow and blue. 'Primary' means you cannot break them down into any components. They are the three basic colours from which all others are made.

In the outer circle we have a number of secondary colours which combine two of the primary colours, and also the gradations of the spectrum in between. Starting at the top and moving in a clockwise direction the colours are: green, blue-green (turquoise), the primary blue, violet, purple, crimson, the primary red, vermilion, orange, deep yellow, the primary yellow, yellow-green, and then back to the first colour, green.

Note that the results of mixing each of the secondary colours (two primaries mixed) yield strong red and weak blue in crimson; strong blue and weak red in violet; strong blue and weak yellow in turquoise; strong yellow and weak blue in yellow-green; strong yellow and weak red in deep yellow and strong red and weak yellow in vermilion.

Now have a look at the colours on the wheel that are opposite one another. They 'complement' each other as they render the greatest contrast between themselves and, as a result, have the most impact when placed next to each other in a picture.

Tertiary colours are mixtures of all three primaries, which make darker, subtler or more neutral colours, such as brown, beige, grey and variations on green and purple.

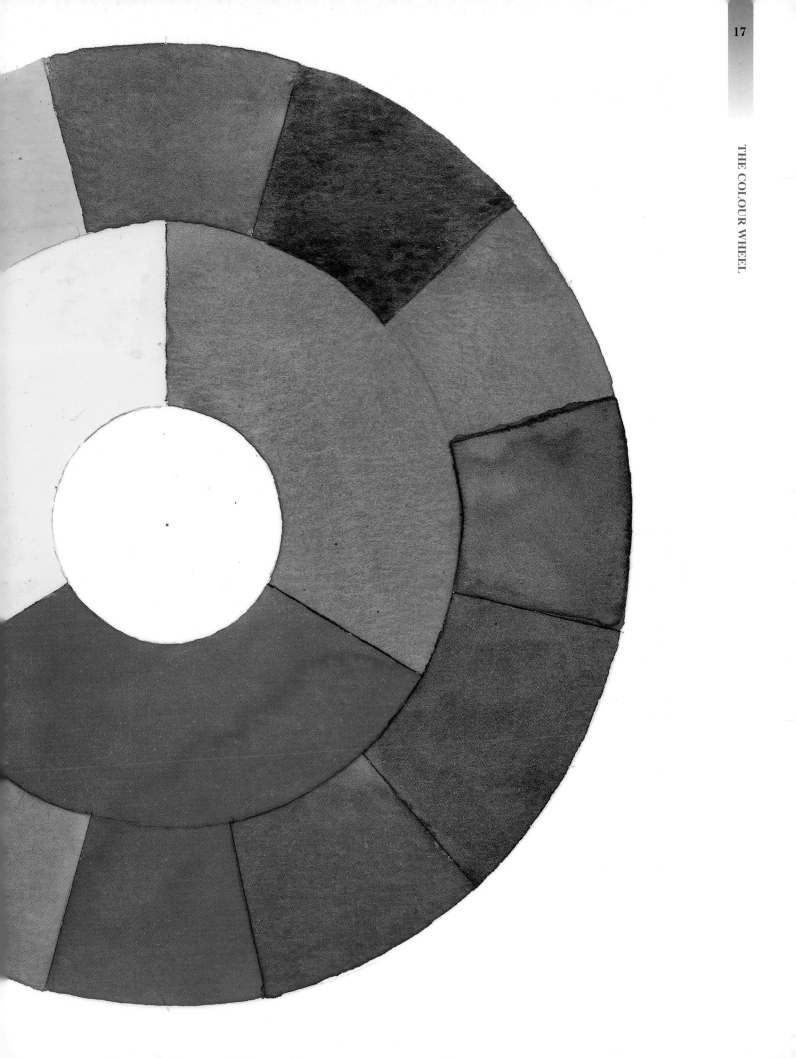

Coloured pencil

Coloured pencils are one form of colour that almost everybody has had some experience of using, from quite an early age. You will need a good range of colours, and as different brands produce slightly different ranges, a mixture of brands can sometimes be to your advantage. Make sure all your pencils are well sharpened before you start, because you get a better texture for the colour intensity if you do. Have several of each colour ready so that you can just change pencils when one gets too blunt. This saves time.

1 To start with, give yourself an idea of the relative colour power of the different pencils by making a chart, drawing a patch of colour, as shown, as strongly as you can without breaking the lead. As you will see, there is a limitation on the intensity of these colours compared with paints or pastels. This means that when you are drawing pictures in this medium you will be producing a rather soft and gentle colour impact. The best results will be from careful and delicate drawing.

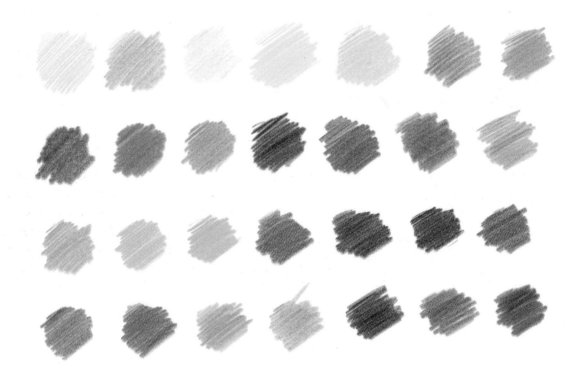

Having made your chart, next try drawing with fairly gentle strokes all in one direction, like shading with an ordinary pencil. Keep the strokes as close together as you can to produce a uniform effect.

2 Then make a series of short marks in various directions, producing an overall texture that looks a bit like wood. I've used brown here.

3 Now try different ways of covering a surface, as shown; first a wandering line which doubles back on itself to produce a sort of scribble area. I've used green, but try several colours yourself.

4 The next series of marks are almost dots and you can decide whether you prefer a scattering of dots or very short marks. Cover the area as uniformly as you can.

5 Lastly, try the exercise of taking closely marked straight lines alongside and across each other to build up a rather denser texture.

6 Now you can attempt overlaying one colour with another. To keep it simple, I have just done strokes all in one direction for the first colour and in a contrary direction for the second. My combinations are yellow-green then green, green then brown, yellow then red, and yellow then blue, but any combination is worth trying, so do experiment.

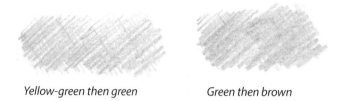

Yellow-green then green　　　*Green then brown*

Yellow then red　　　*Yellow then blue*

7 Finally, practise controlling your pencil by starting with a hard stroke that softens off. Then select another colour; its complementary contrast (the pairs of colours that lie opposite each other on the colour wheel – see page 16) would be best. Start off gently with this one before making the stroke, and colour, stronger towards the end.

Pencil work in greater detail

These sketches show different ways of producing texture with coloured pencils and give some idea of both their possibilities and limitations. Because pencils are easy to control, they are frequent favourites among beginners. Later on, of course, one realizes that the control doesn't come from mental determination but purely from constant practice. Then you can let go of all the control and allow the eye to direct the hand without effort.

1 First of all, just a simple patch of colour where the pencils have been scribbled in all directions to produce a texture. The three colours used were brown, then pink and then ultramarine blue. The blue was put on more heavily than the other two. This produces a smoky texture, which can be built up quite easily.

2 Now we take two areas of colour, a dark background behind a lighter piece of cloth. The cloth is drawn with loose strokes in red, yellow and a touch of blue. There is no attempt to build up a strong colour. For the background, a closely shaded dark blue was first applied, followed by brown and red, and then even heavier strokes of violet. The build-up here is stronger, to create a dark space.

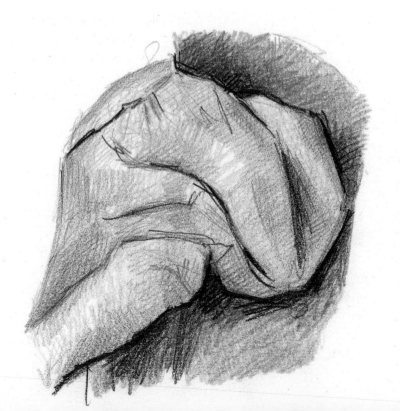

3 Next, we have a drawing by Mary Cassatt, the American Impressionist, of a leg-of-mutton sleeve of the period, drawn with rapid light strokes. The sleeve itself is in green, yellow ochre, brown, blue and violet, in that order. Some areas are more closely covered, others less so, to give change of tone. The background is a heavily drawn-on texture of red and yellow, with some violet in the shadows. Once all the colours were worked up to the desired intensity, they were given added strength by the black outlining of the sleeve shape and deepening of the shadows in the space behind.

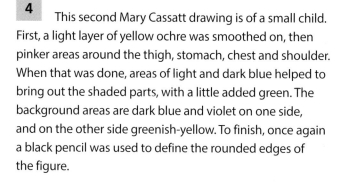

4 This second Mary Cassatt drawing is of a small child. First, a light layer of yellow ochre was smoothed on, then pinker areas around the thigh, stomach, chest and shoulder. When that was done, areas of light and dark blue helped to bring out the shaded parts, with a little added green. The background areas are dark blue and violet on one side, and on the other side greenish-yellow. To finish, once again a black pencil was used to define the rounded edges of the figure.

5 This example is based on a Picasso drawing of 1923. Here the two tones of pink and blue help to provide the dimensional aspects of the head, while the yellow ochre and a brown give shadowy areas on both head and hair. Again, a few black lines sharpen up the image.

6 The Toulouse-Lautrec figure in the fur-trimmed evening coat is done with far less texture, keeping everything very spare and lightly drawn. This creates a sort of delicacy which is quite elegant.

Coloured pencils are best used where you would rather create soft or delicate images.

Masterstrokes

One way of making a distinction between the different effects of light falling on both sides of the face or figure is to make one side of the face a warm, bright colour – a pink or light yellow – and the other side, a cool blue or green colour. This effect of warm and cool colours on the edge of a form helps to create an effect of roundness.

Coloured ink

Fineline fibre-tipped pens in a range of colours represent coloured ink in its simplest commercial form. You can buy them separately or in packs of a complete colour range. The other option is to use a fine dip pen and nib and bottles of either coloured Indian ink or concentrated liquid watercolours that also come in bottles. These work just as well as fibre tips and last much longer.

1 The first task is to test their effect by scribbling a patch of colour with each individual pen. Lay them alongside each other to see how they contrast or harmonize. With this type of ink the colours are usually quite sharp and strong, so the only problem is how to soften them and combine them.

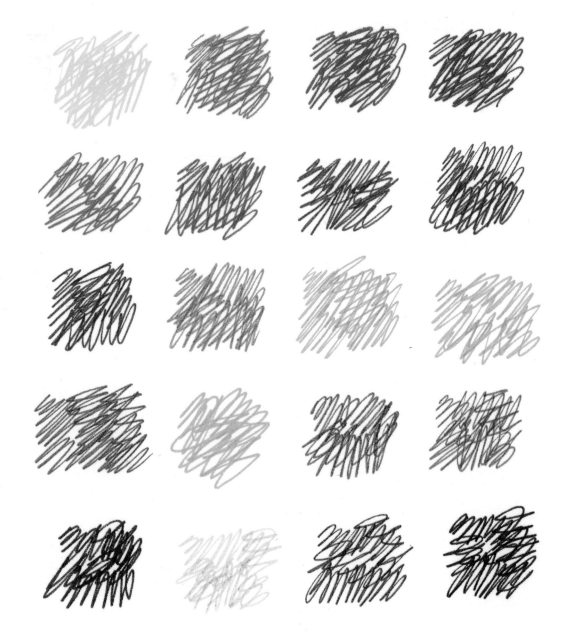

2 One way of pulling two colours together is by making very small marks of colour starting heavily on the left and gradually dispersing them more widely as you move to the right. Then do the same thing with another colour from the right towards the left. If one colour is a lot stronger or darker than the other you may have to fade it out more quickly. In my examples, I've done from yellow to red and from red to green. Note that the yellow-green was helped a bit towards its stronger end by another deeper green.

3 Next, try overlaying strokes of two different colours with the strokes of one colour opposed by strokes of another at almost right angles over the top. I show blue over green, blue over pink, brown over grey and brown over red.

4 In order to get a gentler variety of tone in your colour, do the outlines in ink lines and then use another medium to produce areas of tone within the outlined shapes. I have used coloured pencils inside the square outline of ink. This can work quite well.

5 Lastly, I show a set of marks made by thicker felt-tipped markers which, as you can see, will strengthen any colours where you feel you need a more powerful emphasis.

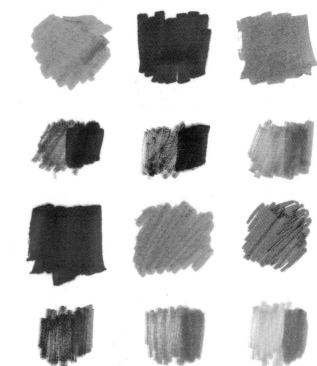

Pen and ink in greater detail

The problem with drawing in colour in pen and ink is rather similar to the situation with coloured pencils. Large areas take so many strokes of the nib to fill them that inevitably there is a large amount of white paper left showing through, and this tends to produce more of a tint than a solid colour. Other problems are building up tones sufficiently densely to hold the form and taking care that marks aren't so strong they dominate. Pen and ink drawings are never quick to produce, but this does have the advantage of allowing you to be more careful in building up your picture. Some people love the medium, while others try it only once. See how you get on.

In these two drawings – one in pencil and the other in paint – I have used David Hockney as my inspiration. Here, the multitude of overlaid reddish tones give some idea of the man's strong rubicund complexion. The hair and the shirt are not too difficult, although the shirt in the original is much stronger in colour. Hundreds of pen strokes are needed to build the colour, so you will need patience. You will also need a fair amount of confidence, because it is impossible to remove the pen strokes once they have been made.

The face of the girl was harder to get right tonally because the pink complexion of the original was quite delicate. This version looks both stronger and deeper in tone. The small broken strokes are better for reproducing a less intense colour but even then, as you can see, it remains quite strong.

In this study of Florence, based on a work by Oskar Kokoschka, the tones and colours are built up by a mixture of small and large strokes, many of them packed quite closely to give an effect of solid roofs and walls. You will have to overlay your marks several times in order to get the tonal qualities you need, and each time you do that, try to vary the direction of your strokes.

Based on an impasto brush painting by Frank Auerbach, of Mornington Crescent in London, this example will test your patience. The less solid medium of pen and ink will force you to build up the areas more gradually. This is where your talent in mixing colours becomes important, because each layer of pen strokes changes the colour of the area being drawn. You will have to decide how many layers of marks you give each area. I made the sky with one layer, which helps the buildings to look more dense and solid.

Colour pastels and chalk

The most expressive way of drawing in colour, as opposed to painting, is by using artists' pastels or chalk, which are made of the same pigments as paints, but held in the form of a stick. Most artists will use both the hard and the soft variety of pastel, depending on the effects they are after, but if you are an absolute beginner at this medium, the hard pastels are easier to start with. They are often also called conté crayons.

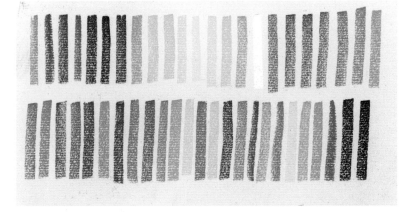

1 When using pastels or conté crayons, work on tinted stock such as Ingres paper, testing your colours by selecting a creamy-beige toned paper and a darker brown-grey. On the lighter paper, first make a sort of chart with one stroke of each colour using the thickness of the pastel. This will give you some idea of the density of tone and brightness of colour for each crayon.

2 Now make a patch of colour, scribbling chalk back and forth over a small area. Then with your finger or thumb, smudge about half of it along the bottom section to see what happens when the colour is worked over. You will not need to treat every colour like this, but do enough to give you an idea of how it looks.

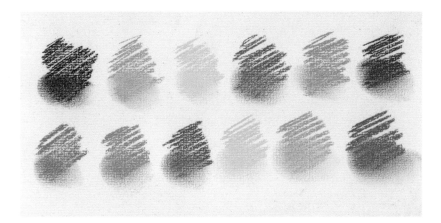

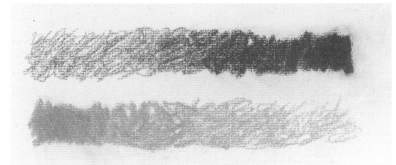

3 Next, make an overall scribble of tone starting lightly and getting heavier and heavier – without crushing the crayon – until you obtain the most solid colour value from each one. This will show how the colour can be varied in intensity.

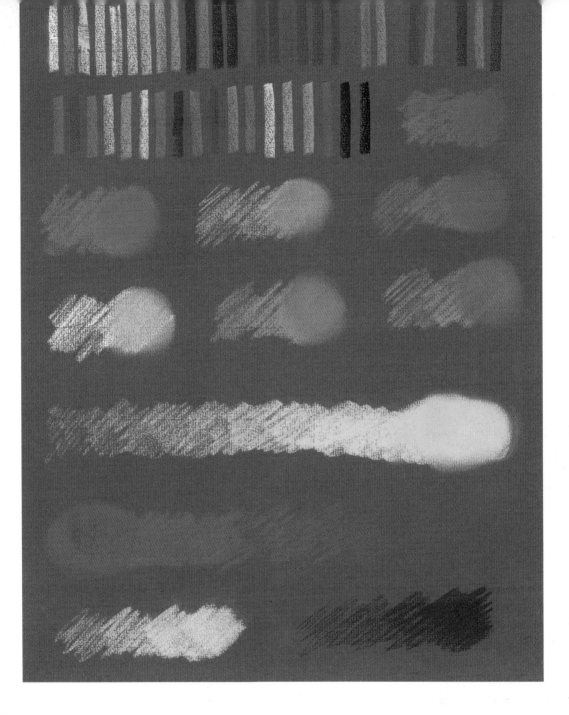

4 Now have a go at doing the same thing on the darker of the two papers. Note how different colours stand out in different ways. A red that looks quite dark and strong on the beige paper appears vibrant and glowing on the dark brown. Notice how the dark tones look heavier on the light paper and more subdued on the dark paper. See how the tonal variation also applies to the smudging exercise. Smudging the colours allows you to produce a larger mass of smoother colour if you require it. Most artists tend to use a mid- to dark tone for working in this medium, but some eighteenth-century artists working on whitish paper produced pictures that looked, from a distance, like oil paintings.

This is a medium favoured by professional artists because it is like dry painting: easier to transport and with much the same possibilities as watercolours or oil paint. However, you will have to invest in a good spray-on fixative to hold loose particles of chalk and prevent your picture fading away.

Some artists don't like fixing their work because it sometimes affects the colour values, especially when the pastel is overlaid thickly, one colour over another. Instead, they shake off the excess pastel by tapping it gently, and keep putting on and tapping off until they get the result that they desire. Nevertheless, to keep it safe, the work will have to be overlaid with a sheet of acid-free tissue paper or put immediately under framed glass.

Pastels in greater detail

Drawing with pastels, you have a greater colour range at your disposal than for anything else, except paint. You will find it most advantageous to work on toned or coloured paper, and there are many kinds available, from cheap sugar paper to more expensive stock, such as Canson or Ingres papers. Any art shop carries a variety of pads or sheets and it is worth trying out several different types until you find the one that suits you best. One pastel artist I know of draws straight onto thick board and I have many times worked on ordinary brown or grey cardboard.

Do different textural exercises to get the hang of working with pastels. If you are using soft pastels, remember to be much gentler in your handling.

1 Put a patch of some light tone onto brown paper and then smudge it with your finger until it looks like smoke or a cloud. Work over the top of this with strokes in lighter and darker tones to see how they can blend in with the soft background.

2 Then try making various marks in a fairly random manner, building up darker colours on the brown paper. Don't smudge this – just note how dark colours still show up against the dark background.

3 Next, try stroking on the colours in one direction only, starting with a light colour. Don't smudge this either, but work over it with something darker in a slightly different direction. Add other dark colours to deepen the tone one side of the patch.

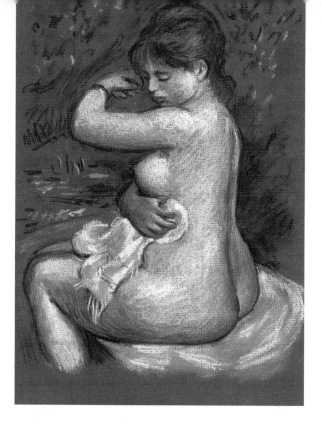

4 Look at this highly simplified copy of a Renoir nude, drawn in pastel on a dark brown paper. First of all, the outline shape was lightly sketched in with a warm pink. Then strokes of a light pink and a light yellow ochre were drawn across the lighter parts of the figure, to build up the rounded shapes of the limbs and torso. Darker, redder colours were put in around the shadowed sides, increasing the three-dimensional effect. Darker colours were further added for the hair, the dark outlines and the deeply shadowed areas, using purple, blue, brown, carmine and a touch of green. The dark background was put in with various colours and the work was finished with the very lightest areas, such as the towel and the flesh highlights in white, sometimes tempered with a little yellow. Note how the pastels tend to follow the contours of the figure, so there is no single way to put on your strokes of colour.

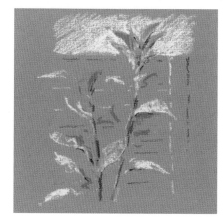

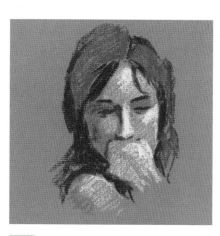

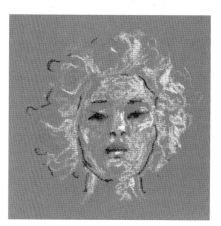

5 Here are three simple exercises where the aim is to keep everything to a minimum; with pastels this can be very effective. I used a deep blue paper and for the plant drawing worked with a light green and a dark green. I then put in a background across the top, finishing with a dark brown touch on the stalks and the fence behind.

6 The girl's head in the second drawing was outlined first in a dark brown. The pale pink followed in gentle strokes over the lightest areas of the face and hand. Next, a richer, warmer reddish tone was used for the shadows on the face and shoulder and, after that, yellow and pink to pick up the highlights. I put a touch of light blue on the back of the hand where the light was reflected.

7 In drawing the final head, I simply scribbled light pink and yellow marks to suggest the hair and face, not too precisely. After that, I used a touch of dark pink for shadows on the face and darker ochre for shadows on the hair – note that none of these marks is very heavy. Lastly, I added a bit of red for the mouth, a little black or dark brown for the eyes, nostrils and chin, and a couple of highlights in white on the nose and cheekbones. I also added a light blue reflected light on the dark side of the face. A relatively acceptable head has been produced without too much work.

Watercolour

When you come to use watercolour, first familiarize yourself with the quality of the paint and its covering power. Watercolour is a very flexible medium and can produce brilliant results in the hands of a practised painter. But even with a beginner, the results can often be quite marvellous because, some of the time, you rely on what are called 'happy accidents'. That is when you get an interesting result even though you don't know how it came about.

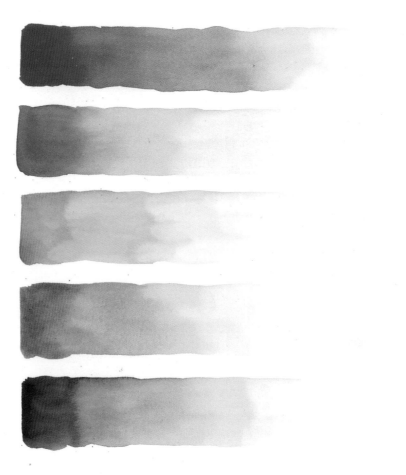

1 Take a large soft brush (a size 7 sable would be ideal) and wet it, then take the strongest tone you can on your brush and lay strokes of each colour next to one another so that you get a clear idea of their relative power. Do this exercise on a piece of white watercolour paper for the best results. Thin paper will only cockle and go wavy.

2 Having made a patch for each colour in your paintbox, find out how the intensity can be reduced by adding water to it. Starting with a solid patch (I began with yellow), brush out from left to right, adding more and more water until the colour has almost faded to nothing. Try to do it as evenly as you can. You will improve with practice but, as you can see from my examples of red, blue, viridian, brown and purple, some have come out much patchier than others. However, this only shows that a patchy quality is sometimes quite acceptable.

3 The next set of exercises will help you to become accustomed to the idea of drawing with the brush. First, form coloured shapes by pulling the tip of the brush across the paper with various twists and turns that are sometimes thicker and sometimes thinner. Then try making short strokes and small blobs instead.

4 Using two colours, make downward strokes where each stroke floods into the next one, producing an all-over patch of colour. Try it with the strokes going up and down alternately.

5 With your paper attached to a sloping board so that the paint will run smoothly downwards, drag the loaded brush across the paper horizontally, allowing each stroke to flood into the one above. Don't make the mistake of going back over the painted areas because this always produces patchy colour effects.

Once you have done all the exercises on this page with your size 7 brush, repeat them with a size 2, which has a narrower point. You can see here that the difference is especially noticeable with exercise 3.

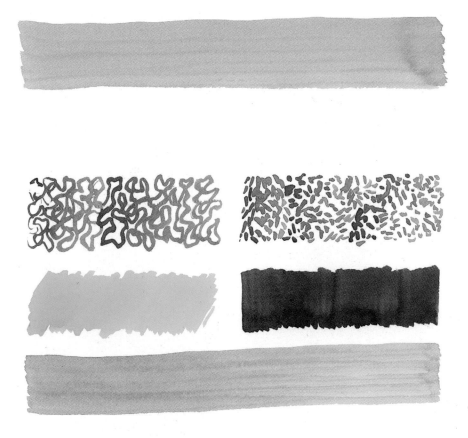

Watercolour in greater detail
A garden scene

Here is a fairly straightforward exercise. Take your time and try to be precise. This garden table picture needs a soft-edged approach to produce a highly effective scene.

1 First lay out the scene simply but with a degree of accuracy. Draw with a brush (size 2 sable), using a light greenish-brown or greenish-grey to give a clear, almost diagrammatic outline. Simple outlines are best, leaving large areas to flood with colour.

2 Next put in the basic tones and colours. The light lies beyond the shade of the trees and bushes, so nothing will be strongly lit except where the sun filters through. Spot in some yellow, as shown. The tablecloth may be white in reality, but in the shadow of the trees looks more purple-mauve. Go over the tablecloth, the chairs and parts of the jugs, outlining the shadows. Now use warm red-brown for the ground, the section of wall at the back and some of the foliage. Take it right up to the edge of the lighter mauve tablecloth and chairs but wait until the former is dry before you lay in this sienna tone.

The last colour base is the dark olive green of the background vegetation and the tree trunk. This needs to be a tone or two darker than the ruddy tone of the ground. Where you have put patches of brown on the vegetation, just paint straight over it. Again, do this after the red-brown has dried. Flood the green over the vegetation and along the tree trunk, leaving a sliver of the brownish colour to indicate the edge. Outline the chair shapes, including the spaces between the back rungs and the legs. With equal care, go around the objects that project beyond the far edge of the table. Notice how the unpainted parts of the objects on the table really stand out, and the table and chairs now look quite light.

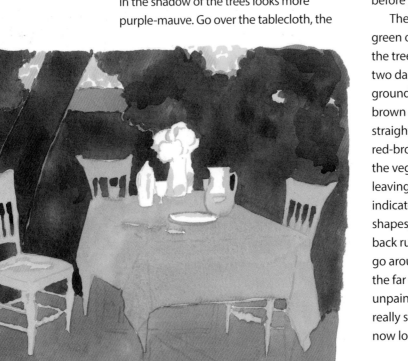

3 Splash in leaves over the entire dark-green background, using a deeper green or a dark brown. Some splashes of blue will also help to liven the density of the foliage. The chairs and table should now be defined more with overlays of purple or blue. The tablecloth should consist of pink and blue tones, with the edge defined in a darker blue. The chairs can have a bit of green mixed in with the tones over them; they need to look slightly darker than the table top.

Splash browns and greens over the ground in flickering shapes, almost covering the original red-brown with these darker tones. Notice how the brushwork hints at the ground's unevenness and the dappled light through the leaves.

For the objects on top of the table, leave the roses almost untouched, except for a splash of pink on one bloom. Blue and purple tones for the vase will help to give the impression of glass. The bottle and coffee pot should be done in browns, greens and blues. Don't be too exact about the shapes – a loose, wobbly edge helps in this sort of picture. Treat the big jug in the foreground in the same way, but don't totally cover the splashes of yellow that were put on at the beginning.

One-point perspective

Your skills as an artist should include the technique of constructing a drawing to give the appearance of spatial dimension on a two-dimensional plane.

Perspective theory attempts to regulate the appearance of the natural world with a constructive formula that makes it easier to draw. Linear perspective was developed in the Renaissance by such great artists as Brunelleschi, Masaccio, Donatello and Uccello. To the human eye, all lines appear to converge on a vanishing point at the horizon, and we see distant objects as much smaller than things that are close to. We know, for example, that a row of telegraph poles stretching away from us along a road are all the same height, yet, from our point of view, those closest to us appear larger than those further away. If our view is distant enough, the poles eventually seem to disappear altogether on the horizon. Here, and overleaf, are two of the basic systems of perspective for you to look at.

One-point perspective shows the apparent objects (blocks on the ground or in the air, and cylinders placed vertically or lying on the ground) with all the vertical poles diminishing in size as they proceed along the limiting lines of perspective towards a central vanishing point lying in the centre of the horizon. This creates an illusion, on the flat surface of a picture, of objects shrinking uniformly in scale as they recede in space and helps to convince us that we are looking at a genuine three-dimensional situation. Of course, these objects would have to be expertly drawn or painted to appear as convincing of their reality as a photograph.

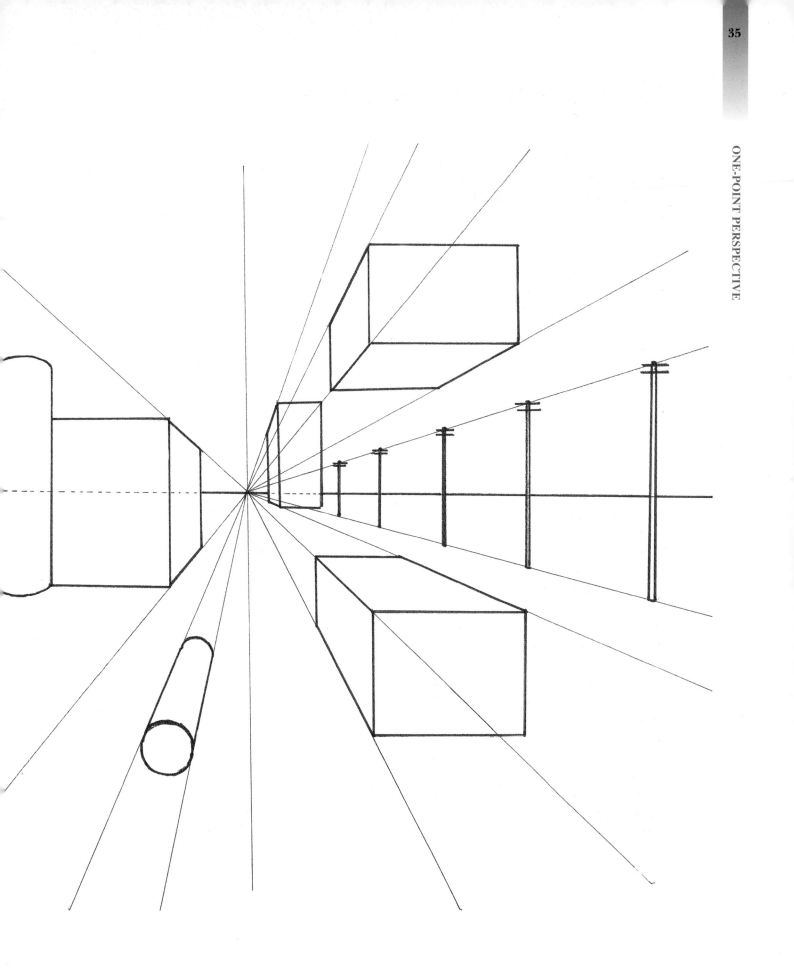

Two-point perspective

The second diagram shows two-point perspective to be more complex, because now we have a vanishing point at each end of the horizon line, with the pair as far apart as our paper will allow. This produces a good impression of three-dimensional objects in space. I have placed three blocks or buildings on the ground (the area below the horizon line). They appear to occupy space exactly as we would see a similar series of buildings in real life. The blue construction lines indicate the areas of the blocks that would be hidden if they were truly solid. Note how that includes all the overlapping areas.

This system is more complicated to construct than the first diagram, but also more convincing in its illusion of depth and solidity. When you come to draw buildings, these technical devices will be helpful. There are other even more complex diagrams for depicting three-dimensional objects but these two are sufficient for most ordinary drawing purposes.

Aerial perspective

This is the name given to perspective as seen through tone and colour. The principle is that if an object is closer to you it will appear more distinct, more textured and with more intense colour than if separated by distance. Technically, the volume of air, with its accompanying moisture, between you and the object of perception creates a mist of refracted light, and produces the effect that you notice when looking at distant mountains: they always appear more blue than elements of the landscape closer to you. Not only that, their texture is smoothed out and the edges of objects seem less distinct.

When you produce a landscape like the two examples here, you can give a greater effect of distance by varying the intensity of the colour and the clarity of the outline.

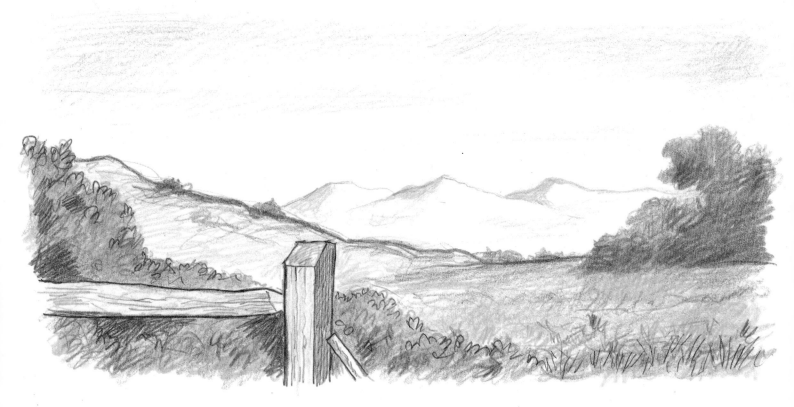

In the first example, the distant mountains are drawn in blue without very much detail of their surface contours. As the eye travels towards the foreground, it notices more intense and warmer colour and more distinct detail, as in the fence post and the close-up grass and bushes.

In the second example, a similar effect is produced and this time it is much clearer that the landscape and building close to the observer are not only more distinct and detailed in texture, their colours are generally much warmer, using yellows and reds to give a more immediate effect to their position in space. Blue shades, which are cool, tend to recede and red shades, which are warm, tend to advance – or, at least, give the impression of doing so. You can observe this effect for yourself when looking at a large landscape, especially on a damp day.

So when you think of perspective, don't forget that colour usage will also enhance the effects of distance and proximity in your picture. Use plenty of detail and warmer colours in the foreground and less detail and cooler colours for the middle ground and background. Describe the features in the farthest distance only in blues and greys.

Masterstrokes

The effect of the source of light on the appearance of distance is also key. If your source of light is behind your main features it has the effect of showing them in silhouette, which tends to make them look closer than they are. So if you wish to retain the effect of distance, make sure that the shadowed parts of your objects are shown in as much tonal detail as possible, to ensure that they don't become a silhouette.

Geometry of composition

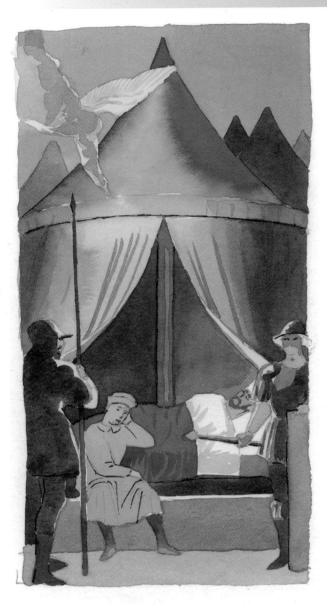

Colour can add greatly to the enhancement of many artistic effects – particularly that of geometry. Correct and careful handling of shapes of colour and tone can help dramatically in presenting convincing images.

For mastery of the geometry of composition, Piero della Francesca proved himself the great mathematician. He invariably divided up his works in a well-regulated geometric fashion, and he was just as much a master of colour. In this fresco, *Constantine's Dream* (c. 1457–58), all the light is on the sleeping emperor and his attendant, surrounded by the warm colours of the tent and the royal bedclothes. The guards in semi-shadow in the foreground seem unaware that the beautiful glow signifies angelic intrusion into the dream of Constantine the Great.

The picture conforms to a strong geometric design overall. There are two subsidiary thrusts of energy through the picture: a line going from the angel's arm to the chest of the sleeping Emperor; and another line from the vertical spear of the left-hand guard to the centre of the angel above.

In Piero's geometric plan, the picture is divided horizontally into three equal parts. The angel and the tent roof make up the top third. The lit opening of the tent makes the central part; and the Emperor and his attendants dominate the lower third. The tent top forms a large triangle, repeated below in the central section by that of the tent opening. Because of the strong vertical running from the point of the tent, down the tent pole towards the foot of the seated attendant, we can infer an inverted triangle in the lower section, although it is not quite so obvious.

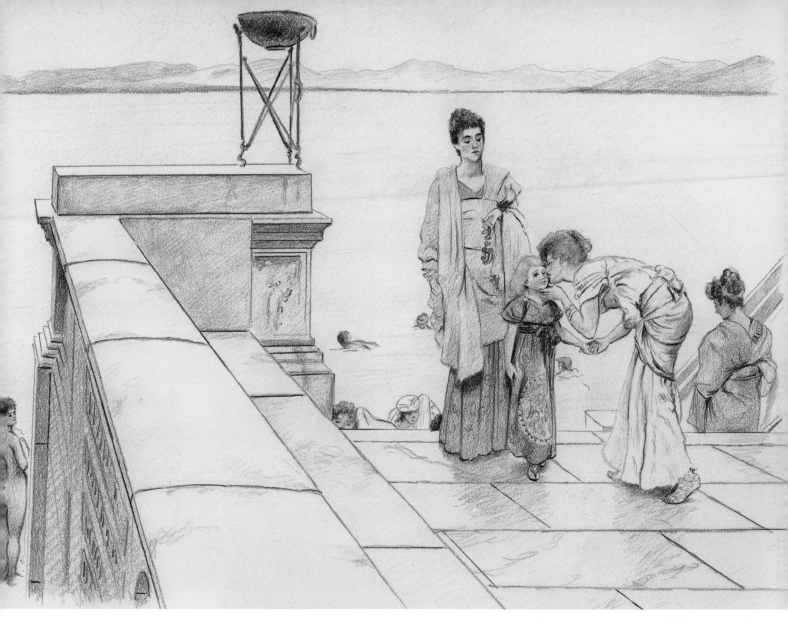

Now, we look at a picture after Alma-Tadema's *The Kiss* (1891). Its spatial qualities are such that I detect a strong sense of geometric design.

First it seems that the horizontal divisions of the space are sevenths of the whole depth: the edge of the lake at one seventh; the top of the beacon ledge at two sevenths; and the top of the steps at five sevenths. Then all the lines of the architecture recede towards a vanishing point at the left end of the edge of the lake. These lines to the vanishing point cut across a very strong vertical through the beacon and down along the edge of the carved support. There also seems to be a tight triangle between the three main figures.

Abstract colour in composition

Colour can play a dramatic role in the effect a painting has on the viewer and many modern artists in particular have used colour with some power. In all the examples here you can see how the main impact on the eye comes from the colours the artists have employed.

Colour used in an abstract way to give a picture a strong presence is shown on this page by two painters of the Impressionist era.

First Vuillard who, with his amazing eye for colour, produced an extraordinary piece of graphic painting, *The Goose*, in the 1890s. The white goose in the centre frustrates his hunters – two baffled gentlemen in top hats and cloaks – and two other helpers over on the horizon. The flat expanse of orange-yellow grass or gravel sets off the white shape of the bird, making it look very poised and confident. The deep-blue sky with its white clouds looks very close. The two black-clad figures in the foreground seem isolated by the strong colour of the ground. There is no attempt to portray depth, although the warm colour of the ground does advance strongly in front of the blue.

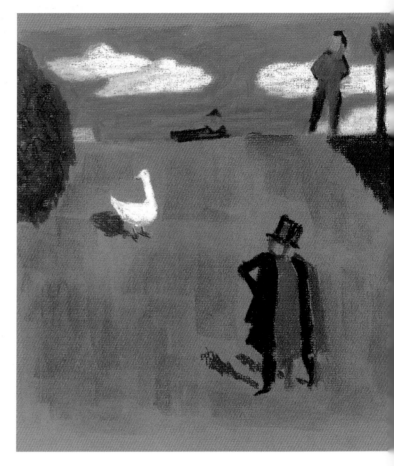

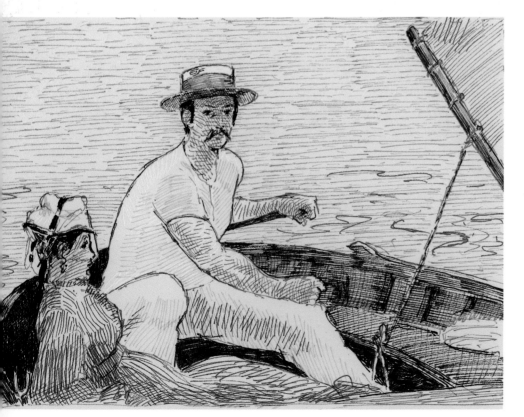

In this scene, after Manet's *Boating* (1874), the water forms the entire background. We can see only the stern section of the sailing boat. In it are a young man steering by the tiller and, lying back, a young woman in a blue summer dress with a hat and a veil. The man, all in white, is set against the blue of water almost like a cut-out. The use of white and blue to set the scene of a sunny day is very evocative.

Matisse was a supreme colourist, one who made colour work for him. In *The Pink Studio* (1911) he floods the scene with one dominant colour, against which all the other colours have to take their place. The strong pink of the floor space sets the scene. Somewhat surprisingly, the yellow rug reinforces the power of the floor space. The rest of the scene seems muted in comparison, even though some of the objects are quite strong in colour. Oddly enough, the device works very well and you do actually perceive the floor as flat.

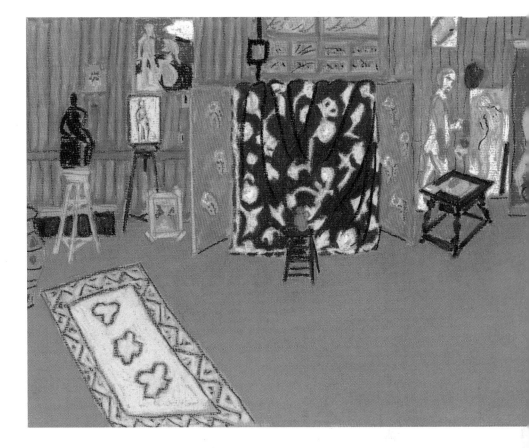

Here too, in David Hockney's swimming pool scene *Portrait of an Artist (Pool with Two Figures)* (1971), there is no attempt to create depth in the picture with tonal harmonies or perspective. The colour of the pink jacket brings the young man forward from the green background, the flat colour alone creating the form in space; the modelling is not strong enough to have much effect. The blue patterns of the pool create a sense of volume against the bright creamy white of the poolside, with the colour giving the major clue to the depth.

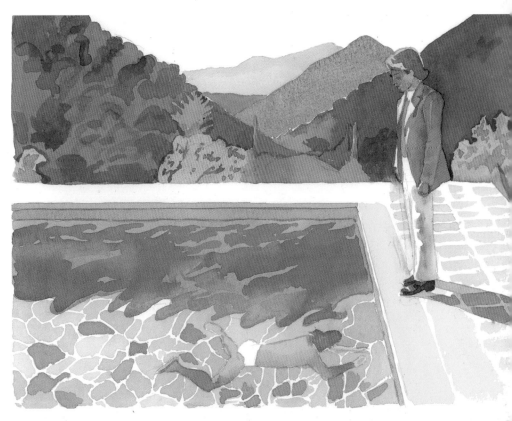

Still life

Still life is in many respects the foundation of drawing practice because it is the one discipline where you can control your drawing set-up and return to it again and again, as long as you need to.

The great thing is to love your subject matter, so only consider objects that arouse your interest in some way. Before you decide upon your still life set-ups, think about their combination of colour values as this should be a strong part of your composition's attraction.

Alternatively, you could set up several still-life compositions that consist of one colour only; for example, a red vase on a red cloth with some strawberries or cherries and a glass of red wine.

These experiments will not only be interesting, but will also teach you the qualities that colours can give a picture. It is a good way to understand the symbolism of colour, and also the way colours work together – notice how the colours contrast or harmonize with each other and how they look against their background.

The actual material of the objects can produce interesting results too, so that you might show five objects, all similar in size or shape, but made of different substances. Also, the contrast between soft and hard edges is always a good point to work on; try placing a soft, draped cloth against a shiny, metallic object or a clean-cut piece of glassware.

When composing a still life, always bear in mind whether one object placed against another gives an interesting dynamic to the picture. Move the objects around until you create the maximum aesthetic interest between them – and that includes the spaces between them, too. Sometimes, simply tipping an item on its side gives a whole new set of shapes and a movement to the setting. Note the reflections in the surfaces of glass, pottery or metal objects, or introduce a mirror into the arrangement, because these change the feeling of the composition significantly.

Having a theme is always a good idea, so for a picture that might hang in a kitchen or dining room, you could show a collection of food, cutlery and dishes, for example; or for a room overlooking a garden, a painting of a vase of simple flowers on a window ledge.

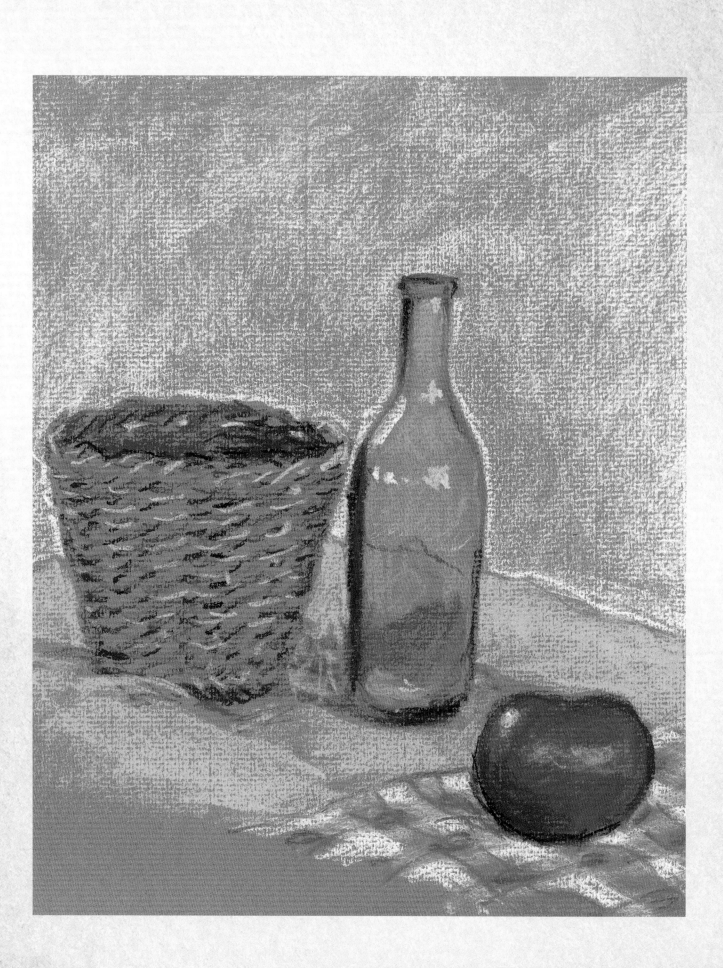

Simple objects

The examples chosen here are fairly straightforward and easily available. Often, when beginning to draw, people forget to include any background to an object. However, with colour work it is better to put in the immediate surroundings because they have an effect on the colour of the object itself.

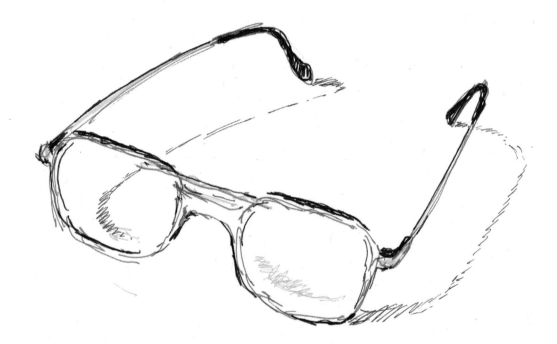

This first example, a pair of spectacles, is drawn in coloured inks, and is a nice, easy exercise because the pen and ink line complements the linear construction of the glasses. The only really three-dimensional effect is the shadow cast upon the surface they are lying on, and the effects of dark and light in the frames.

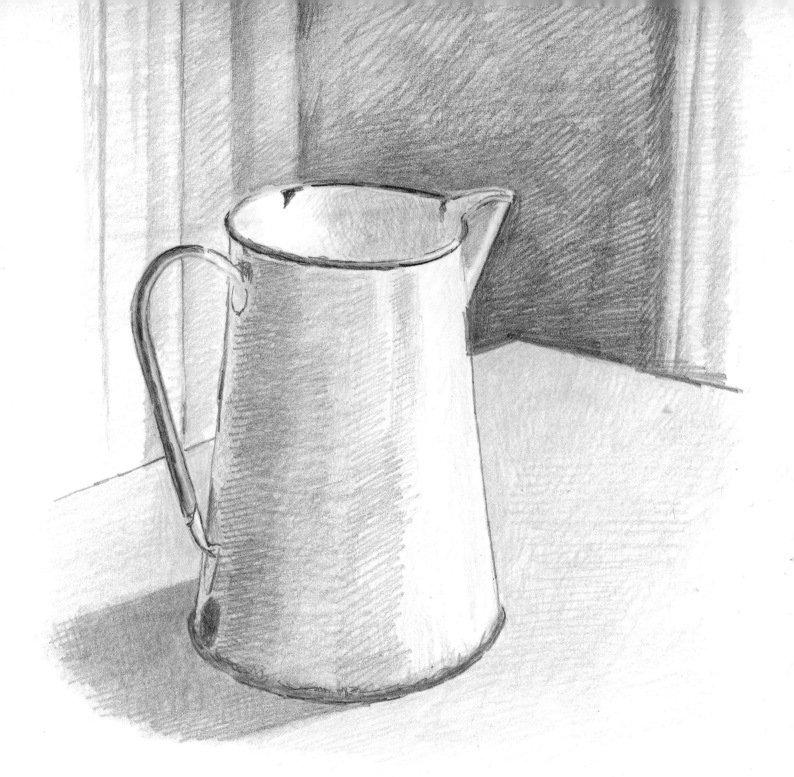

This second example, of an enamel jug in coloured pencil, is a simple shape – a cone cut off at the top with a handle and spout added. The colour is white, so all you have to consider is the shadow colour and that of the background. The reason that this jug stands out so boldly is that the background colours are all stronger and darker than the jug – the feeling of it existing in three-dimensional space is due to the effect of the background colour, as much as the jug itself. The cast shadow across the table-top helps to anchor the object to the surface that it stands on. Notice how the lines of the background shapes are made softer and less distinct than the lines on the jug. This technique also helps to define the space around it.

Remember that the materials and techniques you use can be fitted to the particular objects in your picture. Some things are quite difficult to achieve in pen and ink, whereas others, like the spectacles, lend themselves perfectly to the process.

Materiality

This exercise can go on forever because you will always come across objects that you have rarely drawn before, and there is always more to learn. However, try to find something made of metal, something made of glass, and something natural, like fruit or plants. The examples here are produced in watercolour because it is a very flexible medium, rather difficult to start with, but easy enough to handle when you've made the first steps.

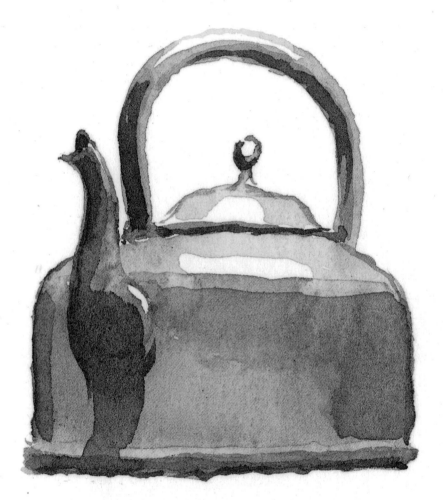

Here is an ordinary metal kettle, not very shiny, but reflective enough. First, outline the shape with the brush, using a grey colour. When that is dry, flood the main light areas at the top of the kettle in a cool light blue-grey and a warmer brown-grey for the lower parts. Don't forget to leave little areas of white paper unpainted to indicate the highlights on the handle, lid and spout. When the first colour is dry, put in a dark neutral grey on the lower part to give darker shadows, but wash it off to one side of the main body of the kettle, so that the surface appears curved. Then, sparingly, put in darker tones on the handle and lid.

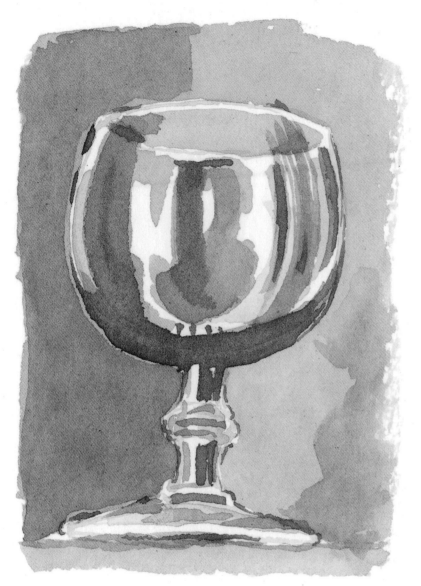

The next example is of a glass. You must include the background here because glass is defined by the fact that the background colour will show through. Again, you have to leave areas of unpainted white paper around the edges of the glass and across its broader facets, to mimic the reflected light that convinces the eye that this is indeed a glass object. Once you have put in the background and the brightest, lightest areas, you can put in the dark ones. This contrast between dark and light is the standard way of showing reflective surfaces. Parts of the outline can be very dark, and some left white.

When you come to fruit, which I have chosen here, the method is similar but the contrast between dark and light is not so great. The purple grapes are painted smoothly round with most of the colour towards the edges of the fruit and, occasionally, across more of the surface. Leave one small area of white paper on each grape completely untouched to achieve the effect of the tiny highlight that occurs on glossy objects like grapes. The edges can be darkened as much as you like and any spaces between the grapes can be filled in very dark indeed. Put in a bit of background tone also, to 'anchor' the grapes in place.

Simple arrangements

This exercise is to get you drawing still life in as many different ways as you can, using the different colour systems. I have chosen a simple set of objects: a basket, a glass bottle and a tomato, on some blue cloth. One of the cloths has a chequered pattern, but if you feel this makes it too difficult, leave it out.

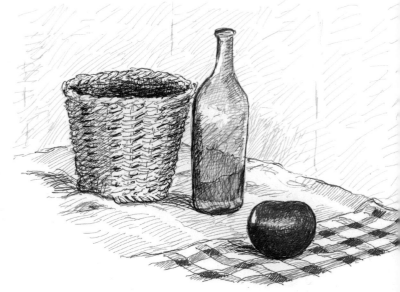

1 When drawing in ink, less can be more, so don't overwork the subject. To begin, draw in an outline with neutral colour; I used brown, but with a grey ink for both cloth and background. Now decide what texture you will use on each of the objects to make them look convincing. Don't over-elaborate in the case of the basket. A scribble effect will help to give dimension where the shadows are. For the bottle keep the transparent look by leaving areas of white paper showing and indicate the background through the glass shape.

The tomato needs a more solid colour – use your brightest red all over, except for the highlight; I put in the front highlight with a yellowy orange, to tone it down a bit. The darker areas I put in with a purple, but sparingly. The cloth can be the least drawn over, the light blue kept fairly open in texture so it doesn't dominate the picture. Lastly, the wall behind can be washed in lightly in pale grey.

2 With pencil, you have to build up the colour to achieve tonal strength. Use a neutral colour for the outline then layer lighter tones over the basket, the bottle and the blue cloth. On the bottle, leave some white areas for highlights. Build up your colours from light to dark. Use your strongest, brightest red for the tomato, except for the highlights. Leave the pattern and shadows on the cloth until last.

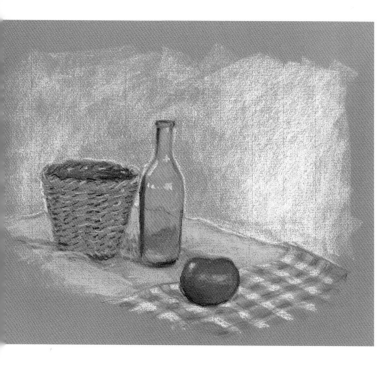

3 This pastel version is drawn on a warm, khaki-coloured paper, on which both strong and light colours register well. Again, sketch out the shapes. Put in the colours on the basket; keep the marks of the weave to a minimum. For the bottle, work in some dull greens, dark brown and a few touches of bright yellow for the highlights. Block in the light blue cloth and the light background wall with varying texture but enough strength to outline the shapes of the foreground objects. The tomato can be worked last as it is the most powerful colour; a strong vermilion plus crimson to give it solidity, and yellow and white spots of highlight. If some of the highlights or shadows appear too weak, strengthen them. Try not to draw over your first marks, but here and there you may need to emphasize an edge. Don't try to be too precise, as you risk losing the soft-edge charm of the medium.

4 Lastly, try watercolour. Draw the outline in a light brown tone using a thin brush with a good point. Leave a tiny edge of white paper between each colour wash, to ensure that two wet colours don't flood into each other. Block in the basket, bottle and cloth with the palest version of your chosen colour; don't forget to leave unpainted highlights on the bottle. As before, use your most powerful red for the tomato, except for the highlights. When the washes are dry, put in all the dark tones on the basket and bottle and the shadows on the cloth. While the tomato is still wet, just drop a touch of purple (not too much or it will go dull) along the lower edge where the shadow would be and let it merge into the bright red. A pleasingly 'spontaneous' effect can be achieved by allowing edges of white to show. These can be touched in afterwards if you wish to get rid of them.

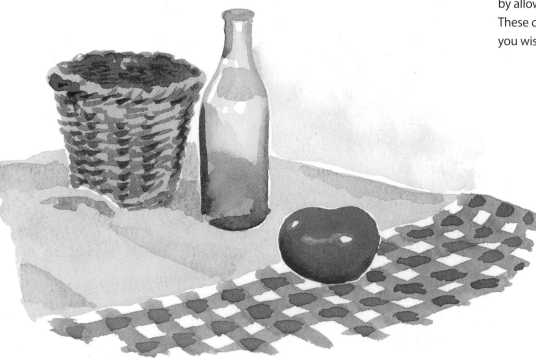

Composition
More complex groups

Now let's look at what happens when the group of objects is more complex in form. For this it is important to be systematic and follow a sequence so that you don't leave bits out – this will make the work easier for you. There is no value in difficulty for its own sake. Method helps to reduce the most complex picture to a manageable scheme.

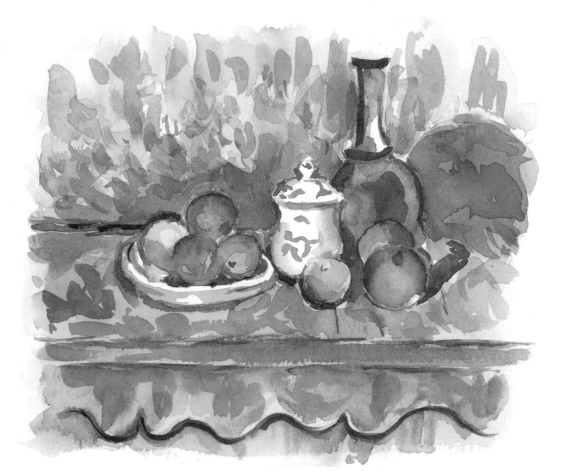

The watercolour above, based on Cézanne's still lifes, shows some familiar objects on a wooden sideboard, plus a rather sketchy large orange object to one side. Drawing with a brush, use a light brown for all the main shapes, including the edge of the sideboard. Taking a larger brush, wash a yellow-brown colour over everything except the objects. Then, put in the yellow on the apples, the orange area to the right and the deep blue of the bottle. With green, brown and purple, put in the texture on the background areas and the surface of the sideboard. Now for the reds and greens of the apples; allow the reds to wash off into lighter and darker shades. Put in the green on the bottle and the pattern and shadows on the china pot. Leave plenty of white paper showing on the pot and as little highlights on the bottle. The fruit bowl can be treated in a similar way to the china pot. Finally, emphasize some edges with extra dark colours, as shown. Put in a dark line along the wavy edge of the sideboard. If they don't look strong enough, splash in any really bright colours like the orange, red and yellow areas. Notice how well this works without it being a super-realist type of picture.

Here is a pastel still life of only three objects, but each one requires quite a bit of thought and care when tackling it. The pine cone has a particular texture and aspect, which is very different from the shiny metal bottle and the earthenware pot. First put down a pale outline of the three shapes in a very light tone on the mid-toned paper. My paper is a rich buff colour.

Once the shapes are there in essence, block in the background colour, in this case blue with some white. A good bit of work on the pine cone should be the next stage, rendering all the basic shapes of the scales in a warm brown outline. This will enable you to put in the projecting edges afterwards with a very light yellow-buff, and to use a dark brown for the deep shadows in between the scales. Play around with several versions of red-brown, yellow-brown and dark brown, to get the feel of this richly textured object.

By contrast, the earthenware pot is much simpler in its strong ultramarine and cobalt blues with a creamy edge, but you need to make sure that the shadows and highlights have the right intensity. With a pot such as this, the dark shadows are less obvious than the highlights.

The metallic bottle, which is a sort of bronze, can be given quite dark shadows on the overall green-brown colour. I used an olive brown, and the highlights in yellow give it the appropriate bronze look. Lastly, the cloth needs to be put in quite strongly in light blue, white and grey, conveying some idea of cast shadows.

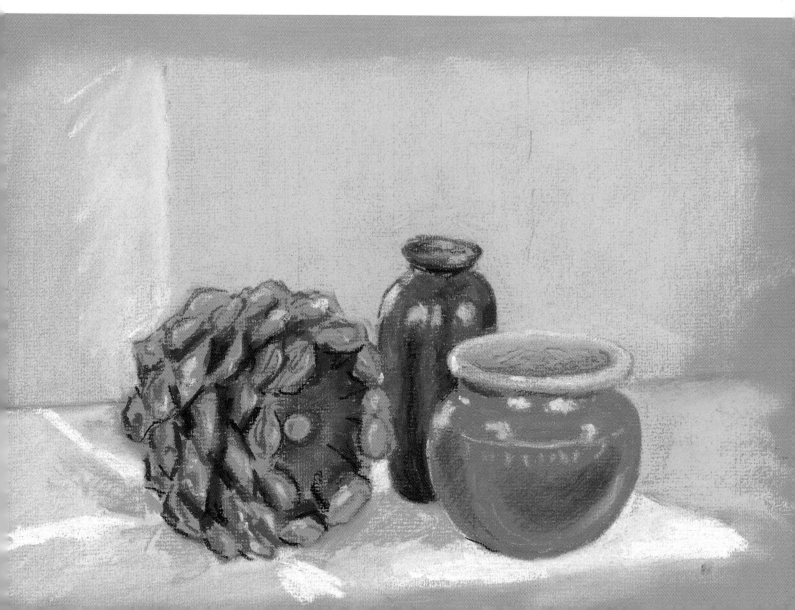

Settings

The setting of a still-life scene is important if you intend to establish a theme or some narrative background for the objects that you draw. Here are three examples of settings in which you could display your talents.

This is predominantly a neutral setting to which you could add your 'props', such as tea-time things on the table, or drinks and cocktails. Maybe you could arrange a small fork and trowel, gardening gloves, bulbs and a sun hat, as if carelessly strewn across the tabletop. The setting itself suggests some story or ongoing action which your choice of objects could reinforce with some success.

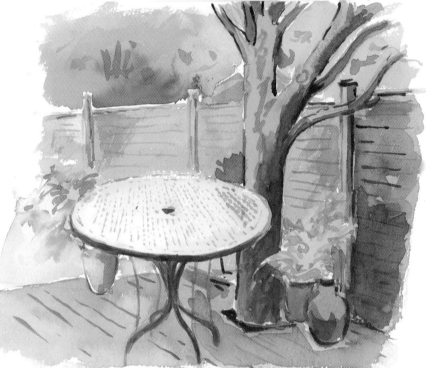

This scene is set out for you, this time using coloured pencil to suit the lightness in tone. I haven't illustrated anything beyond the conservatory windows, but you could easily show a bit of the garden. The setting is fairly natural, although it actually took time and care to arrange. You could choose different objects and so change the scene's narrative.

In the following picture I have set myself a much more difficult task, with a Pierre Bonnard-esque scene of a table spread with the remains of a meal, mainly fruit and coffee jugs. Using a pen and coloured inks, it is quite a *tour de force* to produce something as vibrant as the Bonnard painting, with these strong contrasting colours in very hot tones.

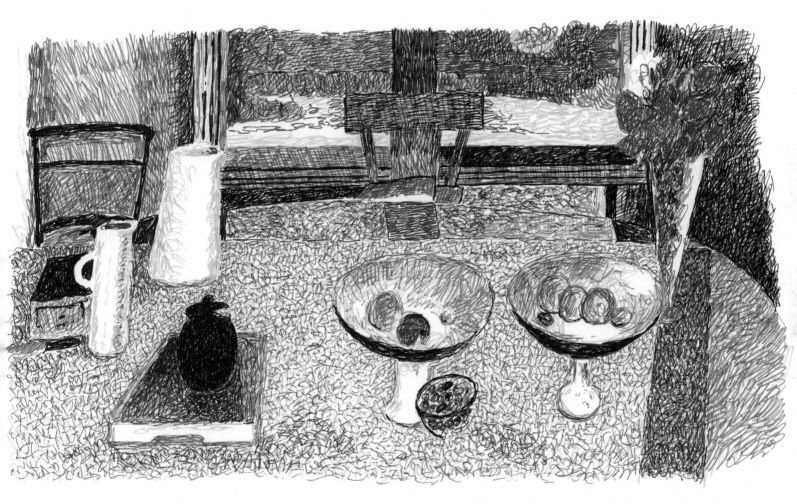

I have attempted to produce the lighter colours by making marks that don't totally obscure the white paper underneath, and where I required deeper colours I have scribbled away to build up denser tones. As long as you can maintain the contrast between the darker more solid colours and the lighter broken colours, then this method can work quite well. But it does take time to put in all these small marks, so don't embark on this sort of task without giving yourself plenty of time to complete it. The brilliance of the coloured inks suits Bonnard's strong colour range and the lunch-table setting is a very good vehicle for a still-life composition.

Masterstrokes

One trick I sometimes use for setting up a still life is to ask someone else to do it for me. You can adjust it to suit your own ideas, but the mere fact of someone else doing it brings a certain element of surprise to your first view of the composition. I often find that my wife has put down some objects randomly and yet they are in just the kind of arrangement that works well as a still life.

Step by step still life

1 This pot has vertical sides and is a simple shape. Because it is light in colour, the interior will not look too dark.

To produce a still-life picture you have first of all to decide what effect you want your picture to have. When I produced the original of this still-life composition, I collected together a number of pots that I felt would make an interesting composition against the backlight of a window. I chose large metal and pottery objects, which were all fairly light in colour. As they were all circular in shape, I decided that I would play on this feature by choosing the perspective of looking down on them when they were close to me, so that the deeper shadows in the interiors of the pots gave a sort of repeat motif and were very dominant in the picture.

As all the items were lit from behind, the main light was diffused and helped to even out the colour values. I decided that I didn't want many strong colours, making this a rather muted piece of work.

2 The green interior of the conical pot is the only splash of colour in the composition, but as it is mainly in shadow it is not too dominant.

3 The large white enamelled jug is a good sturdy shape and has a darker interior as a result of the half guard around the top. The enamel is slightly chipped.

4 The light-coloured wooden bowl, which is smooth and chunky, will give a touch of subdued colour.

5 The drinking tankard, which is made from pewter, is the darkest object in the composition. Its interior looks almost black in contrast to the other objects.

Step by step still life
continued

6 Placing these objects close together, well below my eye-level, I get a repeated pattern of circular, cylindrical shapes, with the light behind them bouncing off the light surface they are standing on. Notice the arrows showing the direction of the light which means that all the shadows are facing the viewer. Draw a sketchy outline of your arrangement before starting on your finished drawing.

7 When you begin to draw these, you will realize that the light colour of each of the objects, and the light background, are assets when using coloured pencil. Because with pencil you can be quite precise in your outline, take your time to get the shapes exactly right in relation to each other. Remember that the space between the objects is as important as the shapes of the objects themselves. Don't get too heavy with your shading or tone – only the tankard and the jug call for strong, dark colours. Notice that the darkest part of this pale still life is the interiors of the pots.

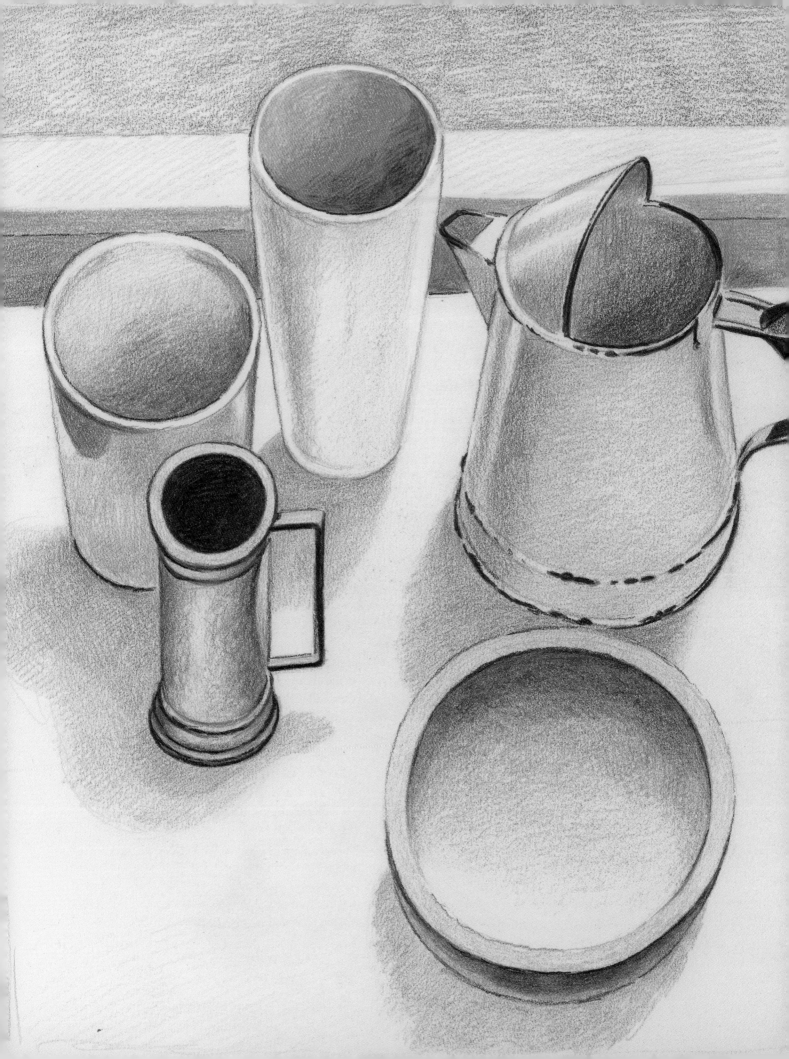

Landscape

Actively searching for a landscape to draw may seem a rather artificial approach – there are landscapes everywhere we look – but you need an area with qualities that you find attractive. Before you start rushing around in search of a good view, consider the area you are working in and adapt your ideas to make the most of a particular environment.

The first and most essential step is to compose your picture. It's a good idea to make yourself a simple viewfinder by cutting a rectangular window in a piece of card and looking for your picture through that, so that you will not be overwhelmed by the immensity of a landscape.

When you survey a landscape full of trees, bushes and grass, take time to look at each area of vegetation carefully and note the immense variety of green that exists in just one view. Distant areas will appear more blue-green, with some greys – cool hues that help to push those parts of the picture right back to the horizon. Urban landscapes have an entirely different range of colour but, even so, some of the same rules apply.

Most important is the influence of distance on colour and tonality, so watch for their effects right at the start of your picture. The ideal arrangement for the light is from the left or right of your position, so that the objects in the landscape are lit up in a way that shows their dimensions.

Ideally, you should be able to see enough of the foreground features to show scale and texture. A large middle-ground area, where trees, rocks, streams, buildings and other features stand closer or further from your viewpoint, will give an impression of depth. Hills, mountains and large expanses of water in the background, when diminished in the cool distance, also give a very good sense of scale and depth to the picture.

So, before choosing your landscape, decide how much detail you want to include and how much of a feeling of space you wish to give it. Adjust your viewpoint to achieve this, by lowering it to get closer, or lifting it to get a greater sense of distance.

Enjoy the qualities of the natural world when you are drawing in the countryside, and likewise the drama and interest of the man-made world in a cityscape, with all its verticals and mass of buildings. Don't worry if the piece doesn't always go right. The fun is in finding out how to do it in practice and, eventually, you reach the stage where you just draw the whole thing by eye and forget the science.

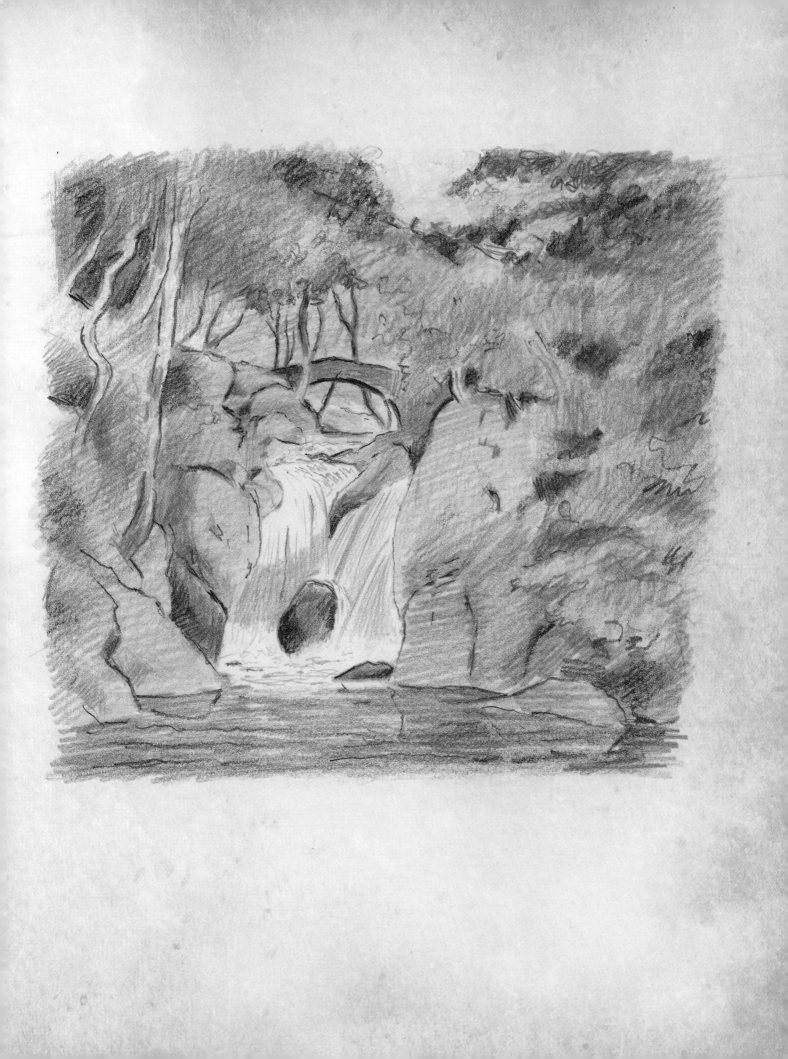

Stepping out

Your first landscape can be the view out of your window or a rendering of your own garden. Here are three very close viewpoints which take advantage of your view being restricted by the window frame, or the limits of your garden fence. So don't try to run before you can walk – start with the easiest view that you can find. It is a good test of your ability to make an adequate picture from a limited viewpoint.

This is a slightly simplified, redrawn version of a view from a window by Bonnard, which I've rendered in watercolour. The view is of darkening skies filled with rain clouds, with red-roofed, white-stuccoed houses in the middle ground. Beyond these are indistinct tree-covered hills. On the table in the foreground, there is a pile of books, an ink bottle and a pen and paper. The interest is in the transition from interior to exterior, suggesting space beyond the cluttered foreground.

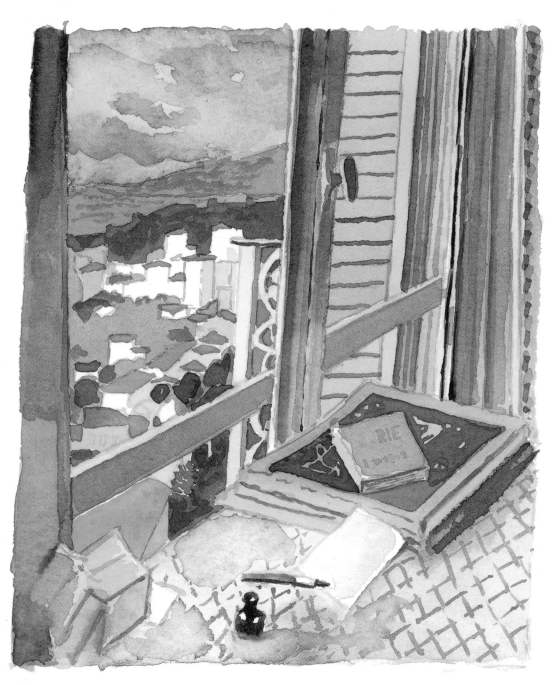

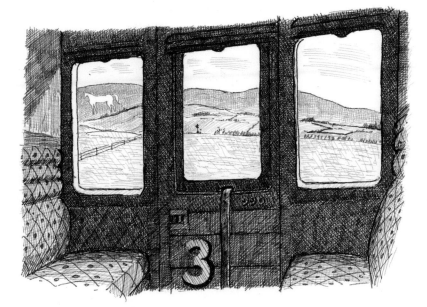

A more difficult version of this theme is taken from Eric Ravilious's *Train Landscape* (1940), here re-created in coloured inks. Beyond the homely interior of an old railway carriage is glimpsed the panorama of a Wiltshire landscape with its famed white horse cut out of the chalk downs. Any train journey allows you to draw a changing landscape. You have to be quick to get enough down so that when you get home you have an accurate reminder to work up into a finished drawing.

This view – drawn in coloured pencils – is from a position on the raised decking immediately outside my own back door. We can see a bit of the Mediterranean pine and fig tree in one corner, my studio/summerhouse and the potting shed. I put the garden chairs on the lawn just to give the scene a point of focus. Your garden or backyard doesn't have to be particularly interesting or shown when the weather is good to make a worthwhile drawing or painting.

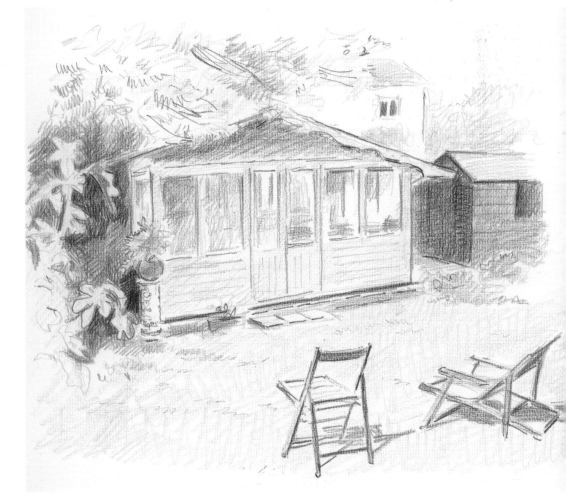

Leaves, flowers and trees

Once you move out into the countryside, all that vegetation will suddenly loom large so it is advisable at this stage to practise your plant drawing. Here are two examples.

First, we have leaves simply outlined in ink, using three colours. Observe how leaves grow in clusters and bunches, so that you begin to see the patterns they make.

The second example is of flowers, based on Emil Nolde's painting of a poppy in 1930. The watercolour I have produced is a fairly rough copy of the brilliant red flower, contrasted with the dark green of the leaves and the yellow blooms beside. A little bit of background colour helps to anchor the blossoms together.

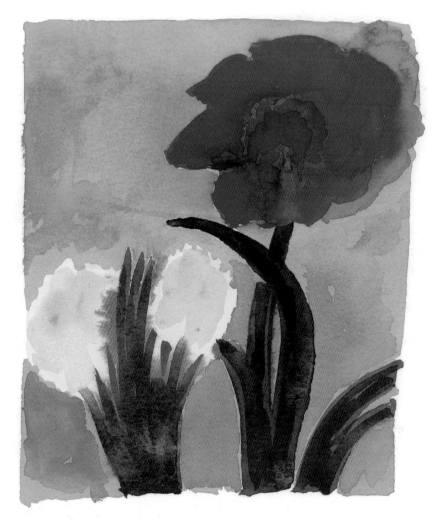

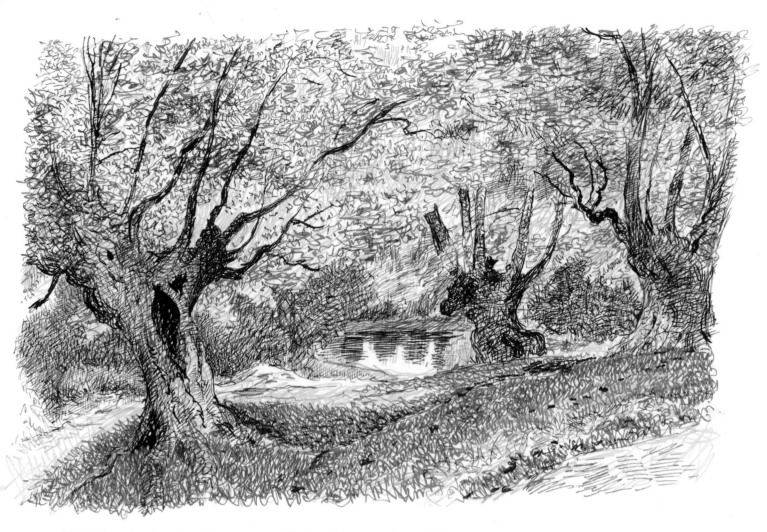

A logical step is taken from plants and flowers to trees, and here are two examples of trees in different locations in the British Isles.

The first, drawn in coloured ink, is from Myles Birkett Foster's Burnham Beeches, painted in 1860. These huge old trees with their wildly spreading branches were painted in the autumn with all the brilliance of yellow, orange, green and brown leaves, filtering the sunlight. The trees themselves appear remarkably dramatic at that time of year; the gnarled, twisted and split trunks, the interweaving branches and the brilliant foliage create a really extraordinary woodland scene.

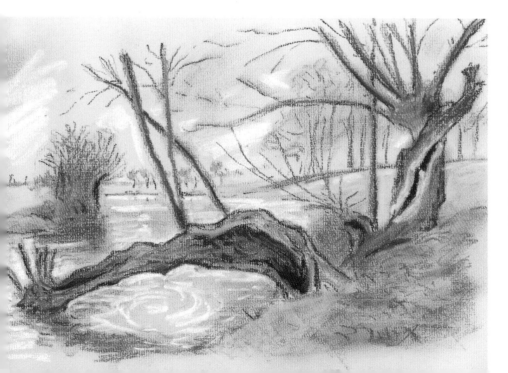

The second scene, by another Victorian painter, A.F. Garden, is of willows on the River Ouse, painted in 1880. I've re-created it in pastels on a beige paper. Again the drama of the twisted and split willow trunks, one of which grows downward into the stream, suggests living beings rather than trees. The wintry or early spring scene sets the bare branches like a network against the sky.

Water

In a landscape, the presence of water really gives a new liveliness to the scene, both in its reflection of the sky and the vegetation, and in its mobile, rippling surface, which is rarely still. Even a still lake or stream has a twinkling effect as the light bounces off the surface. The three images selected here are marvellous evocations of watery scenes by master artists.

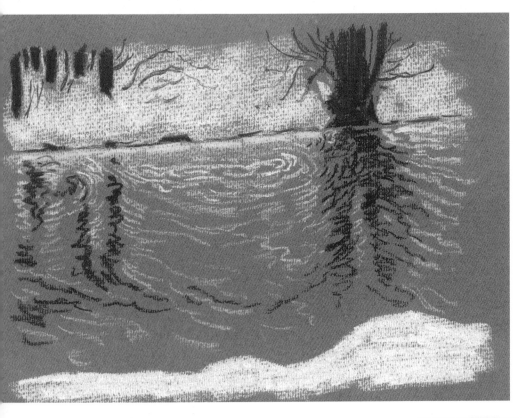

Now let us look more closely at trees reflected in water. I have chosen Gustav Fjaestad's snowy scene *Winter Evening by a River* (1907) where the water reflects the trunks of the adjacent trees in dark and light swirls. Broken reflections in running water is a difficult but very interesting effect to attempt to draw and you can try it in any season.

A rather more summery scene of trees reflected in water is this simplified version of Monet's *Seine at Giverny* (1897), which he produced in a range of blues, greens and whites. My version gives a dramatic effect with the almost monochrome range of strong blues and whites, executed in pastels, which can look very similar to oil paints. The bright gap of white sky seen through the heavily shaded trees is reflected rather less sharply in the water. The greens and blues of the trees are also reflected there, less defined in a more generalized colour splash. It is a very rich and dramatic picture, although tranquil at the same time.

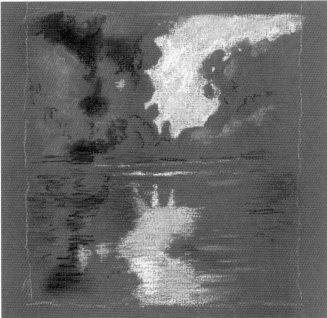

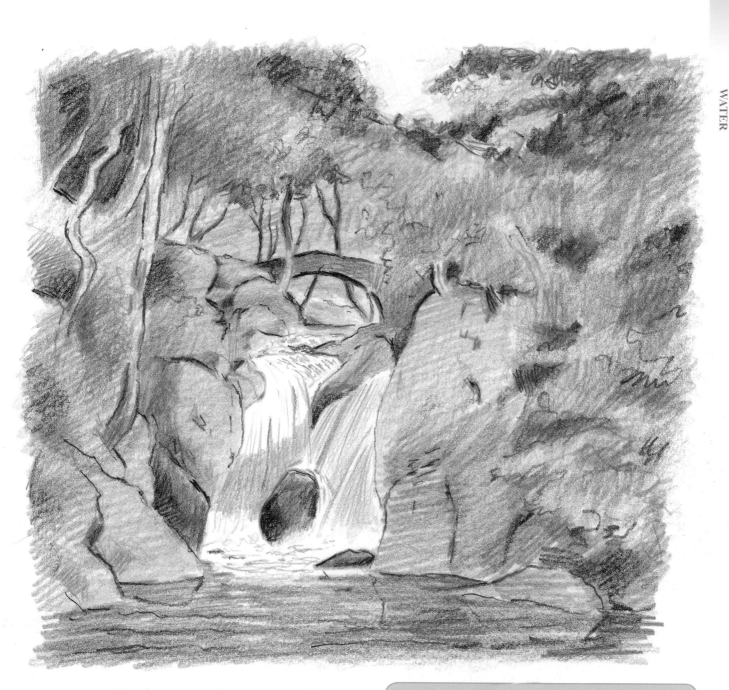

Now for a scene with running water, taken from Joseph Wright of Derby's oil painting *Rydal Waterfall* (1795). Although the scene has hardly changed to this day, my re-creation of it in coloured pencil probably doesn't have quite the power of his, which is partly due to the medium. Pencil is good for gradation and variety in colour, but not so punchy in effect as other mediums.

Masterstrokes

The thing to remember about water is the intense contrast between the lit parts and the darker, shadowed areas. This contrast is part of water's charm and always lends a sparkle to a landscape. You will need to study moving water quite carefully, and the use of a camera is a great asset here. But don't just slavishly copy the photographs you have taken – it always helps if you have spent some time carefully studying moving water and getting a feel for the way it looks.

Step by step landscape

To perform the exercise of producing a landscape, you really need to go out somewhere and draw from life. If you can't manage this, find some good photographs of interesting parts of a landscape that you can put together.

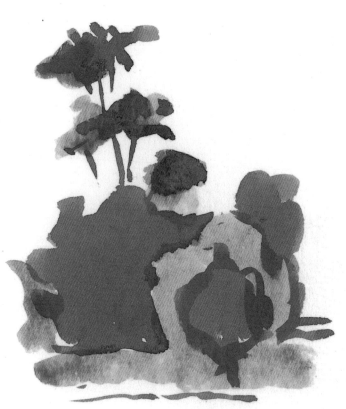

1 First, you need studies of trees to get some idea of what you want your landscape to look like. Here (right) I have made studies of groups of trees and bushes and also a staked wire fence (below). These give me an idea of the sort of scene I'm interested in.

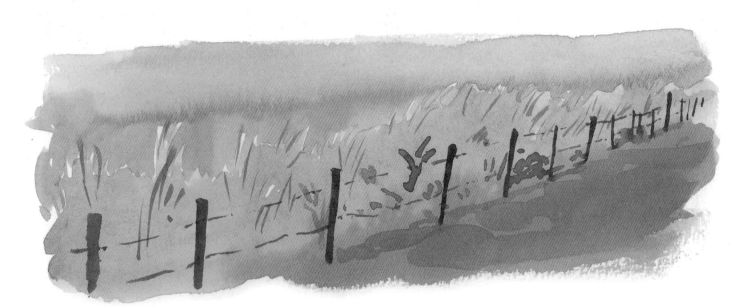

Masterstrokes

The practice of composing a landscape is partly done for you by the area you happen to be painting in, and partly a matter for your own taste and discrimination in what effect you want your landscape to have. It is possible to adjust the landscape that you see in front of you by moving your position a little or by leaving out parts of the scene, or even moving them around a little. Many artists do this, but you have to be careful that the results will all hang together.

2 What I really need is an impressive tree that could be an item by itself. So having found one and made sketches (left and far left) and the drawing (below), I now have to decide how all these elements are going to fit together.

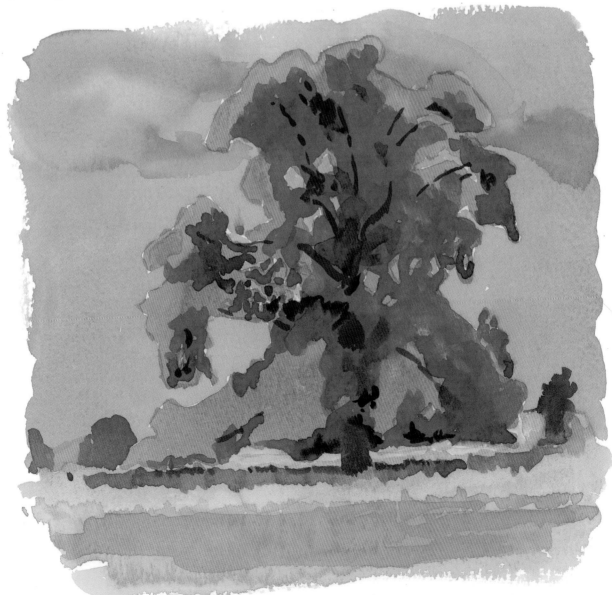

Step by step landscape
continued

3 A quick design gives me an idea of how I shall allow the eye to be led up to the main tree by the line of the fence. This helps to give depth in the picture and acts as a natural indicator to the big tree.

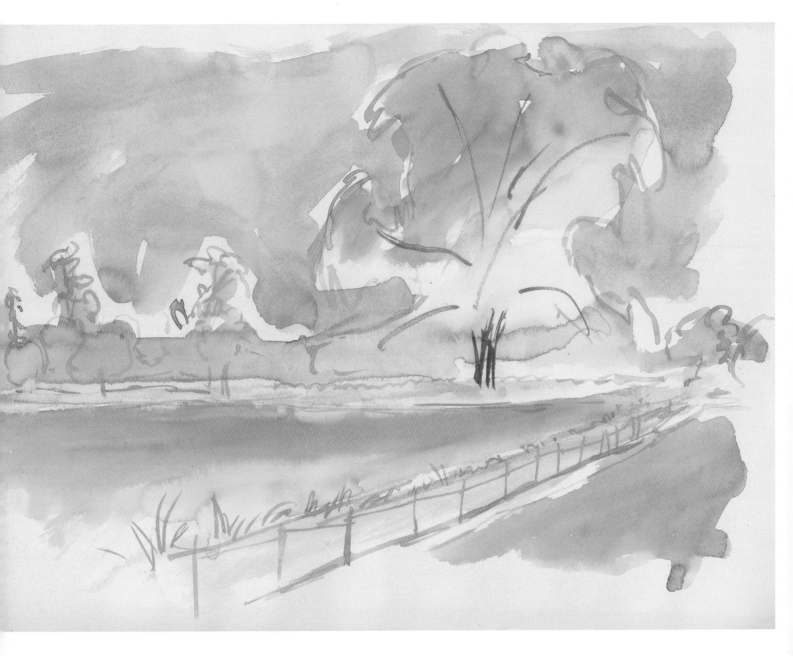

4 Now all I have to do is to go ahead and produce my scene, giving it a summery look with a blue sky, and making sure the drying yellow grasses play their part in bringing the attention to the main tree. All the other trees are much more distant or otherwise insignificant.

Animals

When drawing animals, the biggest problem is that they won't oblige you by staying still, so drawing them from life is quite difficult. It is really easiest to photograph them and then to work from the snaps you have taken.

The best place to start is with the insect world because the creatures are relatively small and not too complicated in shape. Usually, when it comes to insects, museums hold dozens of drawerfuls of them, and it is not too difficult to make quite careful drawings on the spot.

Probably the next easiest is the sea world, with fish of all sorts and sizes. Again, they have simpler shapes than land animals and are quite wide-ranging in colour and pattern. A local aquarium, or even a fish tank in someone's home, can be good for first-hand reference material and, of course, all that swimming around makes the creatures more vivid in your imagination than using a photographic reference.

When you progress to animals on land, there are reptiles, mammals and birds in multifarious shapes, colours and sizes. Observe how the various species have similarities as well as differences, and this should make it easier.

As an artist you will probably want to try your hand sooner or later at a really large creature such as an elephant or rhinoceros. If you cannot reach a zoo easily, then a visit to your local natural history museum can be very instructive. Take your sketchbook and draw the stuffed animals on show. The bird collections in museums are frequently comprehensive too.

Once you are familiar with the shapes of your chosen animals, the next task is to convey some semblance of movement. Several famous artists are renowned for their animal pictures and it's helpful to examine their work.

You can experiment right from the start with techniques for getting the animals to appear more convincing; a drawing doesn't have to be precise in order to create the feeling of an animal in action. An expressionist technique is more likely to conjure up the essence of the animal than a careful, detailed drawing. But whatever you draw from the immense range of animal life, have fun experimenting with various ideas and effects.

Shape and colour

Animals and colour are interesting, because many animals have such extremely strong colour combinations that you can really start to enjoy yourself in representing them accurately. Of course in northern climates you get a lot of rather subdued colour, but in more tropical zones, colour is often quite extravagant. So look around for the most interesting animals that you can find and learn to put in your colour with confidence and enjoyment.

If you have access to a natural history display, find a range of mounted moths and butterflies to draw at your leisure. The example shown here is a Monarch butterfly, which I have produced by first laying down an area of yellow-orange watercolour and then drawing over the top of it in black ink. Because the shape presents itself with a flat surface, there is no problem of representing depth, which gives you an easier start.

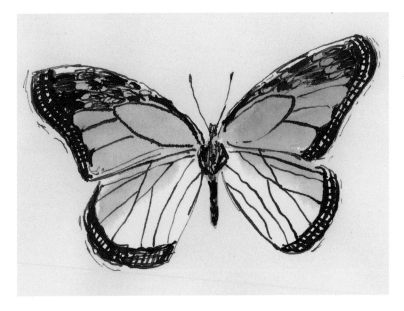

The next example is from the bird kingdom, showing the characteristic shape of the mallard drake. It can be kept as a silhouette without any need to show depth. The patches of colour are well defined and the whole drawing has a very clear pattern and decorative feel to it. You simply draw in each area of colour with the brush and fit them together like a neatly slotting puzzle.

Now we look at two more bird drawings – done in coloured pencil – of a rainbow parakeet and a goldfinch. Once again, thanks to their colour patterning, you do not need to pay much attention to the solidity of the creatures. Keep the areas of colour fairly flat and the combination of brilliant colour and design will be sufficient to give a very attractive impression of the types of bird that you have drawn.

Masterstrokes

When painting or drawing in colour where the colour is flat and unmodulated, it is often best to outline the shape first and then fill in the colour. Do the outline in the same medium as the main colour, or outline in very light pencil, which you can afterwards rub out. You can also draw the outline in pencil or ink on a separate piece of paper, and then put it with another on a light box or on a window and trace the shape through in the main colour.

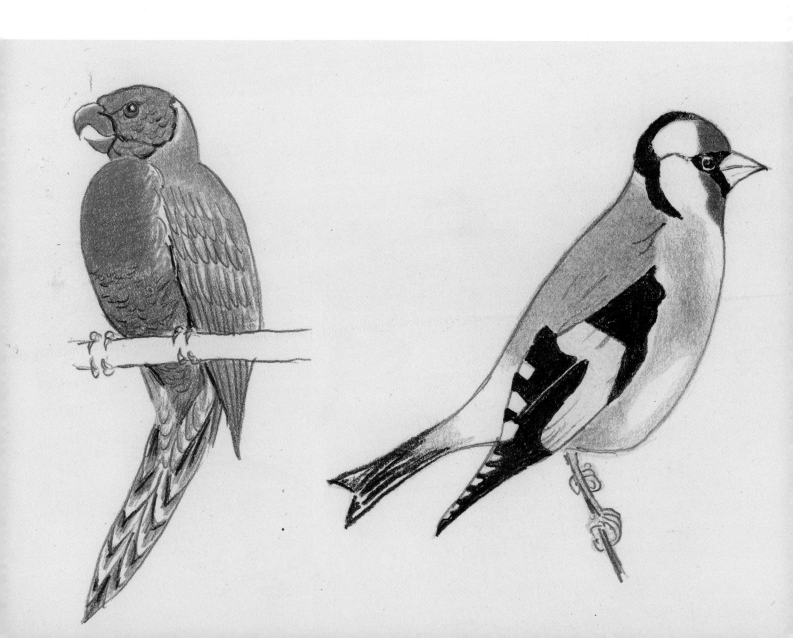

Animals in motion

Here is a frog drawn poised to hop, his shape looking somewhat jerky and awkward. Keep the style simple and loosely drawn in order to give some semblance of movement to the finished product.

Next I show a lizard in mid-scamper. It has a straightforward shape and as long as the texture of the skin looks scaly enough, there are no great drawing problems here either. The colour can be kept to a minimum, with just enough to hint at the sinuous green body.

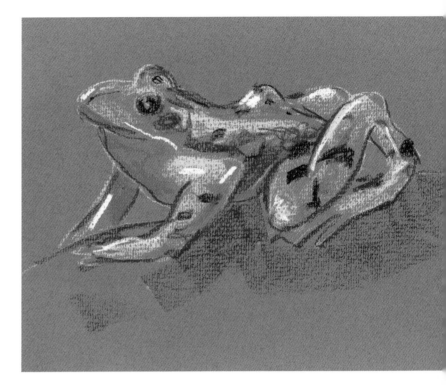

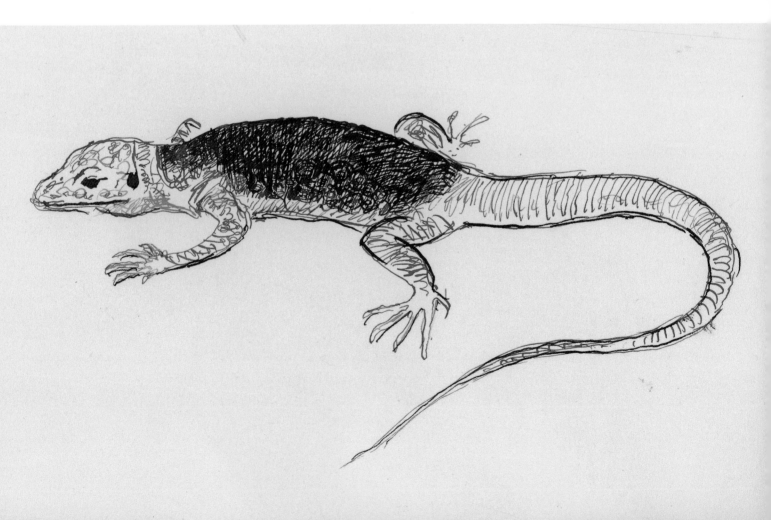

The following drawings continue with the notion of movement and how to reproduce it, but this time I have used coloured pencils in an effort to gain the right effect.

The arctic tern is contrasted against the pure blue sky and this use of a plain background colour certainly helps to set off the movement of the bird in flight. The tern itself is put in very sketchily with no clear details, just as you would see it if it were to fly past you suddenly.

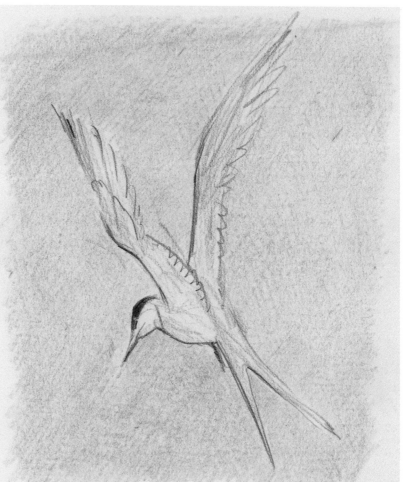

In the next picture, I have a leopard running forward to pounce on its prey. The drawing is similar in style to the bird, in that the lines defining the animal are loosely drawn to give some idea of the powerful muscular activity of the beast. I decided not to represent the leopard's spots very accurately but merely suggested the arrangement of their pattern as this all helps to give the impression of the animal moving at speed.

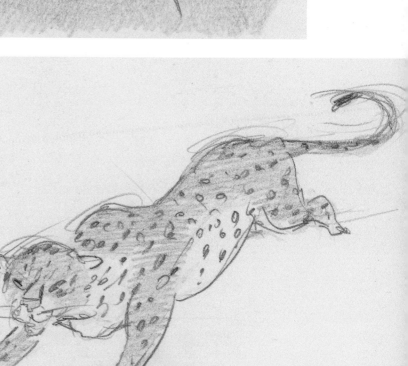

Animals in settings

For an added semblance of reality to your animal drawings, try fitting your subjects into the type of landscape that they might normally inhabit. This means that you need some pictorial references to draw upon. Alternatively, do what the famous French painter Henri 'Le Douanier' Rousseau did, which was to create a magical jungle habitat that never existed in real life but was a product of his sketching sessions amid the lush greenery of the Jardin des Plantes in Paris – the equivalent of Kew Gardens in London.

While dogs often move in their sleep, catching them snoozing in a basket is your best chance of them being immobile for a while. Draw the dog first and the basket afterwards, as the dog may wake up and leave the scene.

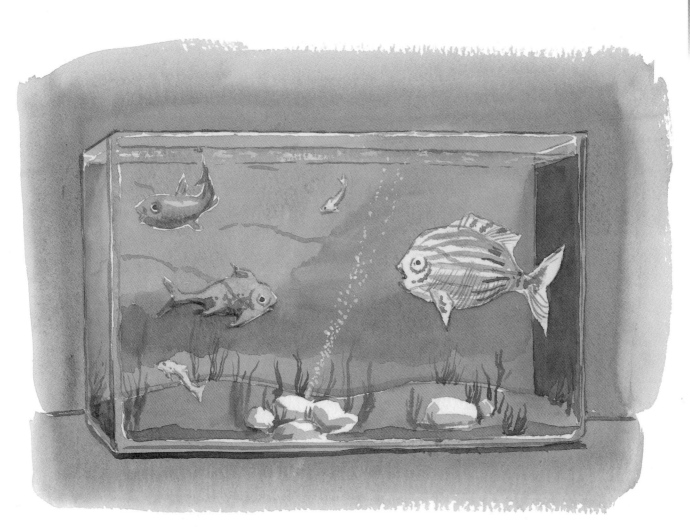

Fish in an aquarium are a colourful and fairly easy exercise, because they continually repeat their movements across the glass tank. Their colours can be very vivid and as their shape is so streamlined they are not too difficult to draw.

This image demands that the cage is drawn with care and precision, while the bird itself is just a colourful shape inside the wire structure.

Step by step animal drawing
(after 'Le Douanier' Rousseau)

In composing a step by step animal picture I have taken my inspiration from 'Le Douanier' Rousseau because his work is so imaginative. The scene can be set by drawing enlargements of plants that you see around you (plants from your own garden or house plants) or work from photographic reference. The animal needs to be an exotic type, like a tiger, to fit in with Rousseau's fantastical scenes.

1 You will need to study plants close up, although you do not need to have access to real jungle plants because quite ordinary ones will do, as long as you make them look much bigger than they actually are. Also, you will need to vary the shapes of leaves a little and make them look more luxuriant.

Having got enough in the way of leaves, you will also need to find some type of flower to be your jungle blossoms. Choose something florid and pink or red.

2 You will need to make drawings of a tiger or some other exotic animal. It is probably easiest to work from photographs.

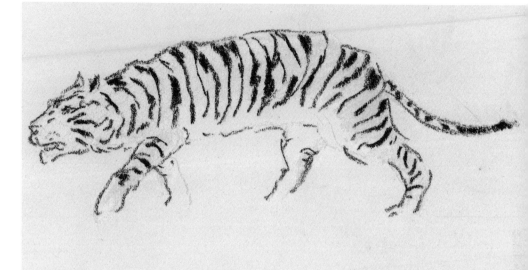

3 Having got your plants and wild animal, the only thing left to do is to design your picture by sketching the main outlines of the scheme. You can produce the details as you go along – it's more fun and probably produces better results in this type of picture. Don't hold back on the colour.

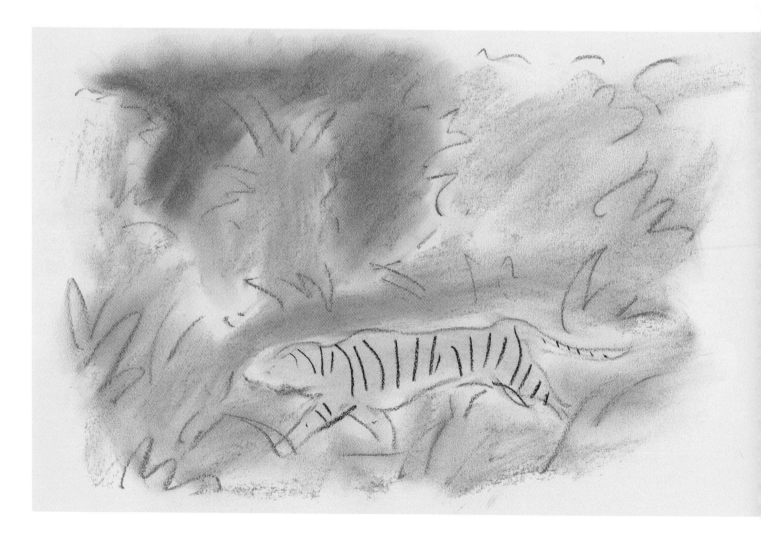

Step by step animal drawing
continued

4 Using a toned paper, and pastels for their rich colour values, you can construct a jungle landscape where plant shapes jostle and overlap each other.

5 Next, show a moon or sun glowing brightly in the deep azure space of the sky. Make the most of the decorative values of the plant shapes and the animal's markings – don't try to be too realistic. The whole charm of this type of picture is in its decorative, dream-like richness.

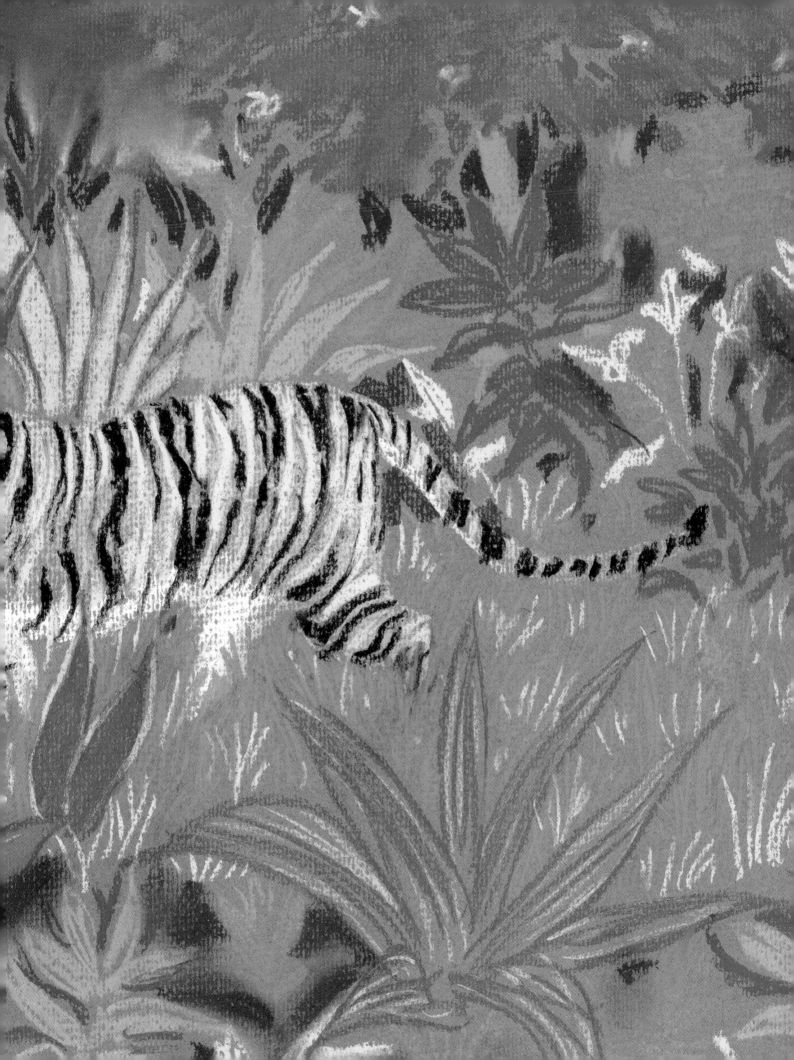

The human figure

Drawing the human figure in colour provides certain obstacles for you to conquer before you become really proficient. One major fact is that the coloration of the human body encompasses a wide spectrum. There are few truly strong colours in the human skin range, but a host of very subtle tones.

Apart from obvious differences in skin colour between various races, the complexion of each human being reflects any number of hues, according to whether you are looking at that particular individual in the cold light of winter in the north or beneath a brilliant summer sun, closer to the Equator. Then again, there is another range of tints caused by the effect of electric light. And not only do you have the colour of the skin to consider, but also the colour of your model's clothes and of the background setting, which will affect the appearance of the skin against them.

With people, it is always a case of getting them to co-operate with you in order to draw them effectively. It may not be a question of drawing the whole figure, but sometimes just an arm, or a foot, or the head and neck. And don't just draw the head from the front, but from every possible angle: it all increases your ability to do 'life' well.

Your models will need patience, as it takes time to produce a good representation of the human body. A life class at a local art institute is one of the best ways of learning to draw the human figure and the experience will never be wasted. But even without tuition, you can still prevail upon friends and relations to sit for you. Change the poses frequently – standing up, lying down and positions where the body is extended and curled up in turn all help to increase your range. And remember to look carefully at limbs and torso when they appear foreshortened, in order to see how much the shapes of the body alter when seen from different angles.

Finally, clothing obviously makes a big difference to the appearance of your model. Start by asking them to dress simply, so that you can see the shape of their body clearly. As you improve, you can ask them to wear something thick or heavily draped so that you can test your skills by seeing if you can work out what is happening beneath the fabric.

Proportions of the human figure

Before you leap into your first figure drawing, pause to study the proportions of the human figure so that you have some idea as to how it can be drawn more easily. This diagram gives a very simple view of that complex object, the human body. Viewed from the front, the height of the average adult – male or female – is approximately seven-and-a-half to eight times the length of their own head, measured from top to bottom. Women are generally smaller boned than men but the ratio of head to overall height remains the same.

Notice how the halfway mark of the human figure is the lower end of the torso and the top of the legs. The navel is three units down, as are the elbows with the arms lowered.

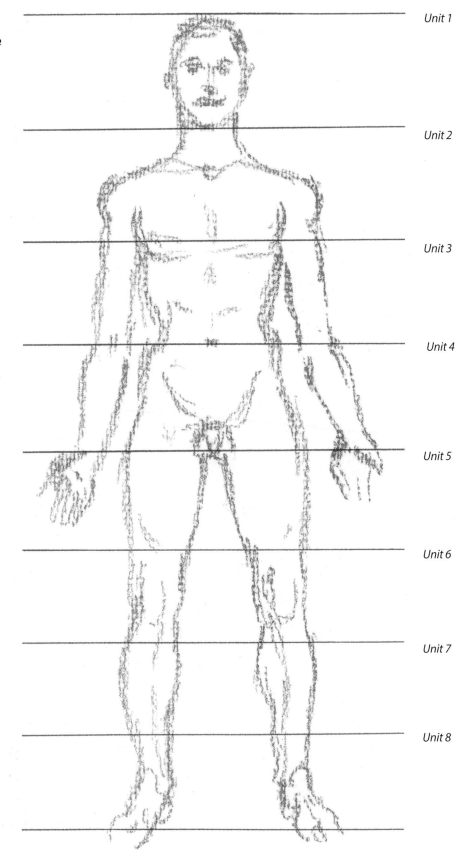

Unit 1

Unit 2

Unit 3

Unit 4

Unit 5

Unit 6

Unit 7

Unit 8

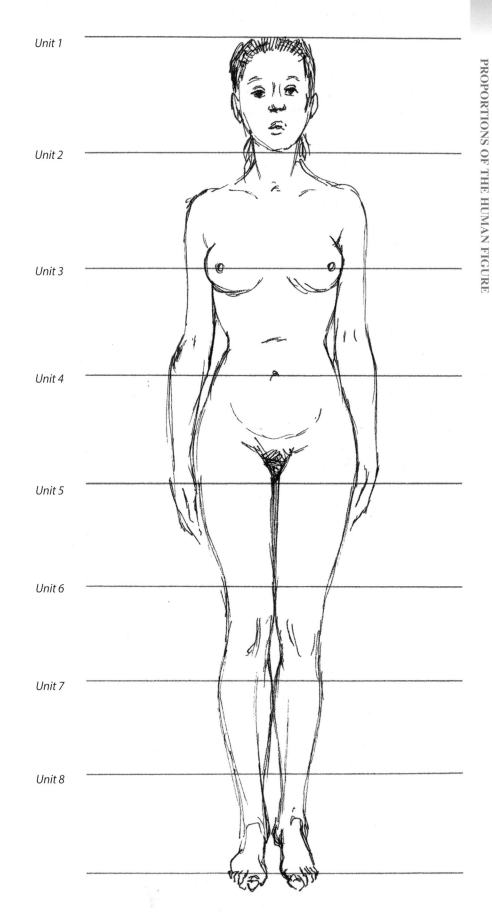

Unit 1

Unit 2

Unit 3

Unit 4

Unit 5

Unit 6

Unit 7

Unit 8

Notice that the second unit down is the level of the nipples, and the knees come about halfway down unit 6.

Light and dark tones

Here are three figures, one on a white background, one on black and another on a midtone, which demonstrate how to balance out your tonal range. The problem with drawing a figure in colour is the risk that you run of making the final result look too melodramatic. The range of tones on the human body is quite subtle, but they do go from cool or cold colours to warm, rich tones. The sort of light that is used makes a difference – sunlight being so strong that it often washes out contrasts of colour, and artificial light being restricted and therefore changing the natural colour of the body.

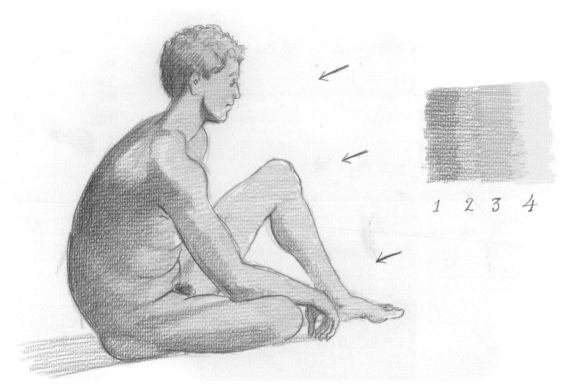

1 2 3 4

✒ *Masterstrokes* ✒

When drawing the human form, the simple understanding of the geometric shapes and the overall tones are far more important than the details. Without this care in the main shapes and colours, the details won't work to your advantage. So, take immense care with the large, main shapes and colours of the body, and then the details will really take off.

The man is seated, facing the source of light, and since he is drawn in coloured pencil, there is no great contrast between the very darkest tone and the very lightest. Note how the shadowed area is mostly in cool blue tones and a warm yellow has been used in the areas where the light is falling on the figure. The numbered patches show the colours used.

For maximum contrast on the black background, I have used pastels. Note the use of warm and cool colours for the light and dark areas; and to add a touch more warmth to the picture I've put in a rich reddy-purple to prevent the blue from becoming too dominant. When working like this you should do the initial drawing in a single colour first, to establish the overall shape of the figure.

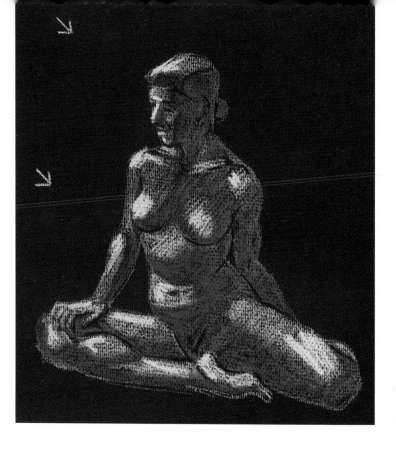

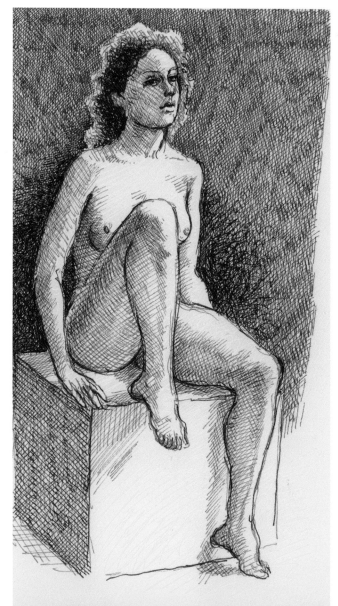

This dark, densely sketched background in deep blues has the effect of throwing the lighter, yellow-toned body forward into relief.

Limited colour

These two drawings do not try to produce any strong colour at all. Quite often you will find that what you draw is subdued in colour naturally, so that in order to make the most of your picture you need to consider the values of tone for creating the same sort of effect as colour.

These two nudes are drawn in different styles but both in the medium of pen and ink. The first is a copy of a Picasso ink drawing and I've tried to follow the method he used, giving a similar emphasis to the line. The second is drawn more heavily and I've added some colour washes to give a more spatial effect to the figure. The contrast between a simple line drawing and the addition of washes of colour shows how much even limited colour can achieve.

Movement in figures

When it comes to reproducing moving figures, there is always the same problem. How much do you show clearly and how much should the drawing be blurred in some way to make it convey movement? The question may be approached in two ways. You can either hope that your drawing is dynamic enough to hold up as a moving image, even if everything in it is crystal sharp and clear, or you can bring in some distortions and fuzzy edges to give an impression of movement, as if you have taken a photograph with a slow shutter speed.

The first picture shows a dancer suspended in mid-air, in the middle of a great leap, and it is obvious enough that this pose could only have been captured by a camera. Clearly the figure is not supported by anything except her own impetus.

The next picture is also a scene captured on film. The movement through the space around the figure can be marked by traces of his hands and feet – blurred by their rapid movements – to show that this is all happening in real time.

So, both solutions work in different ways. Try each of them and decide which one you prefer for use on any particular occasion.

Foreshortening and perspective with figures

The next two pictures demonstrate what you have to look for when using foreshortening and perspective on the human body. Below are two figures lying down on a surface with their heads towards us and their feet away from us.

The man is lying on his back and his head appears very large in comparison with the rest of his body. Notice how the shoulders, arms and chest are the next biggest part of the body and how the legs appear quite tiny, with the feet sticking up and looking almost too big for the legs.

The second figure – of the girl lying on her front – is similar in proportion but, with her arm stretched out towards the viewer, her hand looks unusually large in comparison with the rest of her body. You will no doubt have noticed that I have used the patterns on their clothes to emphasize the disproportion: the striped pattern on the man's chest and the horizontal stripes on the girl's back are the kind of trick that can help your attempt at this sort of foreshortening.

These next two images demonstrate the same kind of foreshortening, but from the opposite end of the body. Here you see a girl lying on her back with her feet towards you, and subsequently the feet and lower legs appear large, the upper legs and hips less large, and the upper torso and head quite small. The arm extended towards the viewer has a large hand and a much smaller arm in comparison.

The man lying with one knee bent again seems to have enormous feet, large legs and a reduced upper body and head. Notice how the underside of the chin is prominent in both cases. These drawings were done in ink and wash.

Details of the body – hands

When drawing the figure, it is always necessary at some stage to look at each portion of the body in order to get it really accurate. Hands are quite complex, and it can take some time before you become proficient enough to be able to draw them easily, but it will come if you persevere.

These two open hands, showing the palm, will be very familiar to us, since they are seen from the viewpoint of the owner. Notice how the movement of the thumb changes the character of the gesture.

1. The open hand with its fingers straightened out looks flat and fin-like.

2. Another fist, obviously masculine, but with the thumb closed around the fingers. When the hand is in a fist, draw the whole shape first, picking out the detail afterwards.

4. Here is a hand in a fist which has quite a rugged quality about it.

3. A hand extended towards the viewer, relaxed but not totally open. Notice how the outside of the fingers are in shadow and contrast with the palm, which is lit.

5. This hand is partly closed and partly open, demonstrating the versatility of hands.

6. A gesticulating hand suggests fluidity of movement.

Details of the body – arms

To draw arms effectively, you need to look at them from every angle. Remember, the arm is larger in section nearer the body and thinner further away, towards the extremities. The only time this appears not to be so is through foreshortening, when a thinner section, such as the wrist, can seem as thick as the bicep, due to the effect of perspective.

1. This arm with the hand resting on the hip shows clearly the main shape, including the large muscles in the upper arm and the delicacy of the wrist.

2. With the arm raised and the elbow closer to the viewer, the forearm looks bigger than the upper arm, which is foreshortened.

3. The arm is larger in section nearer the body and thinner further away, towards the extremities, as seen here. The only time this appears not to be so is through foreshortening, when the wrist can seem as thick as the bicep as a result of the effect of perspective.

4. Study of the joints will help you to create a convincingly life-like arm. Draw it with a simple outline to start with, then gradually increase the subtle curves to produce the shape of the muscles more accurately.

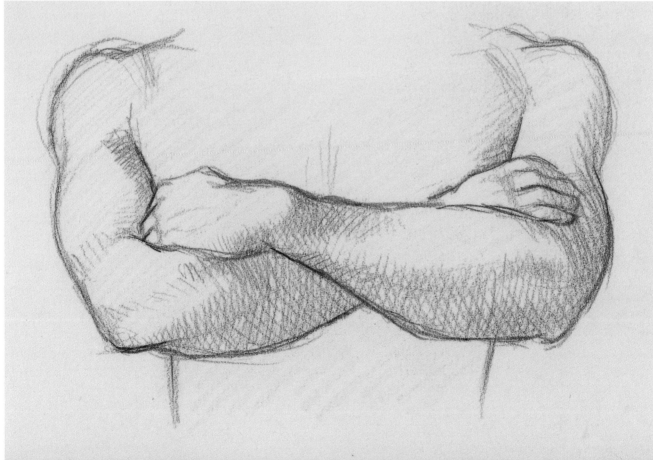

Details of the body – legs

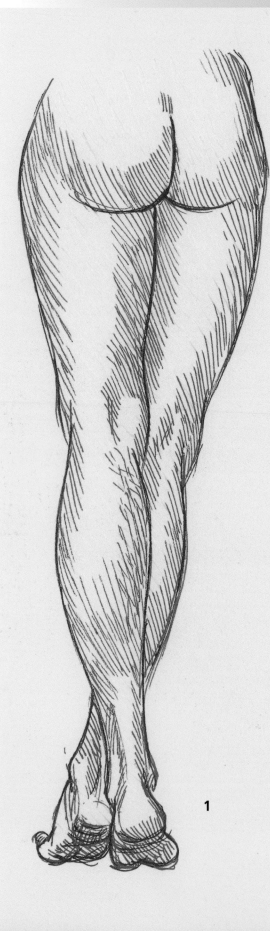

These examples of legs in close-up show both the full-length view and the legs folded up and bent.

The back view of a pair of female legs (1), drawn in coloured inks, shows the full stretch of the thigh and calf muscles and gives a good idea of ideal proportions. The other two sets of legs show very clearly the appearance of bent knees – in one case, a large bulky shape (2), and in the other example, the way the two legs curve softly around each other when they are crossed (3). Notice how the calf muscle of the upper leg forms itself around the thigh muscle of the one beneath.

1

2

Masterstrokes

Drawing the parts of the human body is never a waste of your artistic time. It will teach you more about drawing than any other kind of drawing that you can think of. It is at one and the same time the most difficult and the most satisfying exercise and will help you to become an efficient draughtsman quicker than any other kind of work.

3

Details of the body – feet

These examples of feet, seen from the front, side, underneath and from three-quarter view, provide a lot of information as to their structure. They have been drawn in pen and ink, in pastel, in coloured pencils and in brush and watercolour. Feet are probably the most simple of all the details of the body and it doesn't take long to familiarize yourself with them. Try drawing your own hands, feet and legs in a mirror or directly; the practice is always valuable.

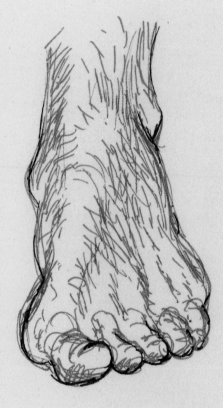

1. The most difficult view is from the front where everything is foreshortened.

2. A straight side-on view shows the typical foot shape that we all recognize.

3. The foot seen from below is unusual and needs a bit of study to get it right, but it is not too complex.

5. A foot coming down as if walking, shows how the toes lift up to help the action.

4. Feet arched and up on their toes are not too difficult except when seen from the front.

6. The typical shape of the foot of someone standing in front of you is seen here from the three-quarter view. Note how the flatter part of the foot connects with the ankle joint.

Step by step figure drawing

When you come to produce a picture with a number of figures in it, you will need to have some sort of theme or idea about how they are all going to fit together into the scene. It could be totally abstract in that it would only be a group of figures arranged in a format with no particular reason for being there. But usually there is more fun in choosing a theme to put your figures together in a more natural and narrative way.

1 I chose as an easy option the perennial holiday beach scene, which most of us have had some experience of, and which shows off the human figure to some advantage. So I drew a young woman sitting as if on the beach, then a male companion lounging with his hand up as if calling to someone.

2 Then I added the classic bathing beauty, kneeling on the beach and applying sun-tan lotion.

3 Another character was an older man with a bath towel, looking somewhat uncertain.

4 I next added a young man with a beach ball, which he appears to be about to throw.

5 Here is a youth with a small bucket, from which he is throwing water.

6 Another girl next, looking as though she is being splashed.

7 And finally a middle-aged woman with dark glasses, just standing. All these figures are in their swimming costumes so we have a classic scene of bodies almost in their natural state in a familiar situation.

8 Now you have to set the scene. First the sea, making a nice broad horizon across the middle of the picture, then a bit of rocky cliff to one side and an island and some yachts on the horizon. The beach is divided into a lower part near the sea and a higher part closer to the observer. On the lower part is a deck chair and a large bag. On the higher level are placed two beach towels, one of which has a large umbrella or sunshade planted near it. Beside the towel without the sunshade are a sunhat and an open book.

Step by step figure drawing
continued

9 Next, the task of placing the figures in the scene. The first thing was to put the couple together on the towel with the sunshade on the left side of the picture. On the other beach towel, which is strongly coloured, I placed the young woman. She has no need for the shade as she is building up her tan, and she has a sunhat to keep off the hottest sun. Behind her I set the young man with the beach ball so that the lounging man appears to be calling to him. Behind him is the uncertain man wondering what is going on, and the middle-aged woman who is probably waiting for him to move the deckchair closer towards her. In the space between the three in the foreground I put the youth throwing the water and the young woman reacting to that. And so I now have a beach scene with a logical enough story to give credence that it actually happened. All these figures have been observed by me at some time or another, and it was only a matter of remembering what they looked like in order to draw them. However, if you are contemplating a scene like this it would not go amiss for you to draw some people in that situation first or even take some photographs of such poses.

Portraits

Portrait drawing is frequently the type of drawing that people would most like to be able to do, so that they can make reasonable likenesses of their friends and relatives. The first important thing is to understand the structure of the head. Without attention to its general shape, you will not be able to make a very convincing portrait, or even a caricature. When people start drawing the human head there is a tendency to concentrate on the face of the sitter, and it is often drawn larger in scale than the overall size of the head. This is natural enough, but something you will have to correct for the future.

Start practising either from life, which is the most effective way, or from clear photographs. Gradually you will become accustomed to the relative shape of any head and then, even if you still don't quite capture the likeness, at least you will have a head that looks as though it belongs to a real person.

When it comes to tonal values in the portrait, you may well find that the colour of the human face is not always uniform. If a person has quite dramatic changes of colour in their facial features, you could be tempted to put them in very strongly. However, this could reduce the structural composition, turning it into a caricature of the real person. In order to avoid this, grade your colour gradually from one part of the face to the next and the result will look more natural.

Then, of course, you will need to look at the various features of the face, until you know how to draw them from any angle. What identifies a face as belonging to a specific person is the particular arrangement of the features and their relationship to each other. So, carefully consider the arrangement of your sitter's features, even if you have to measure them to make sure that you have the right proportions. Interestingly, most people's features are very similar to each other in terms of measurements, but there are lots of small distinctions of shape and form that will make all the difference when you come to draw. Our eyes are so accustomed to scanning faces that they discern even the tiniest differences between one face and another.

As you go about your daily life, study every face that you see. It always stands a portrait artist in good stead.

Proportions of the head

These two diagrams of the average adult human head are to help you become familiar with the general proportions. In the first, I have drawn the female head full on from the front with the head upright and directly facing me. The male head, usually larger-boned, has exactly the same proportions.

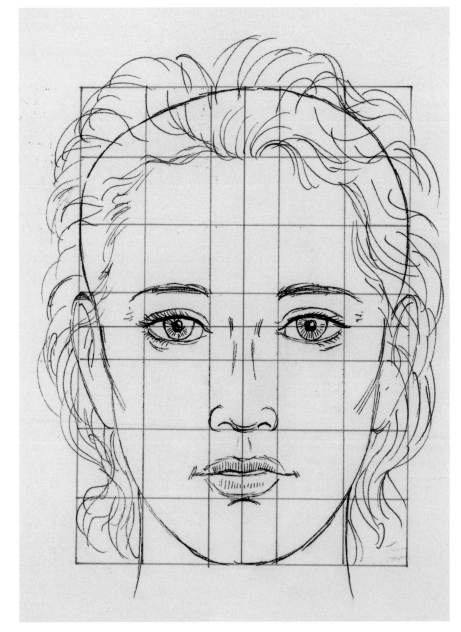

Vertical readings of the full face:

1. The length of the eye from corner to corner is exactly one fifth of the overall width of the face, viewed full on.

2. The space between the eyes is one unit, or the same as the length of the eye from corner to corner.

3. The widest part of the head is about two units from the top of the head.

4. The nose extends over two vertical units, three units from the top of the head and two units from the bottom.

5. The eyes are situated halfway down the head. Nobody believes this at first but it is so – we usually see only the face and ignore the top of the head, which is usually covered in hair.

6. The hairline at the front is one unit down from the top.

7. The nose is one and a half units from eye level to the base of the nostrils.

8. The bottom of the lower lip is one unit up from the base of the chin. This should help you get the position of the mouth right, because it is not halfway between the base of the nose and the chin, as you might assume.

9. The length of the ears is two units, the tops are level with the eyebrows and the lobes align with the base of the nose.

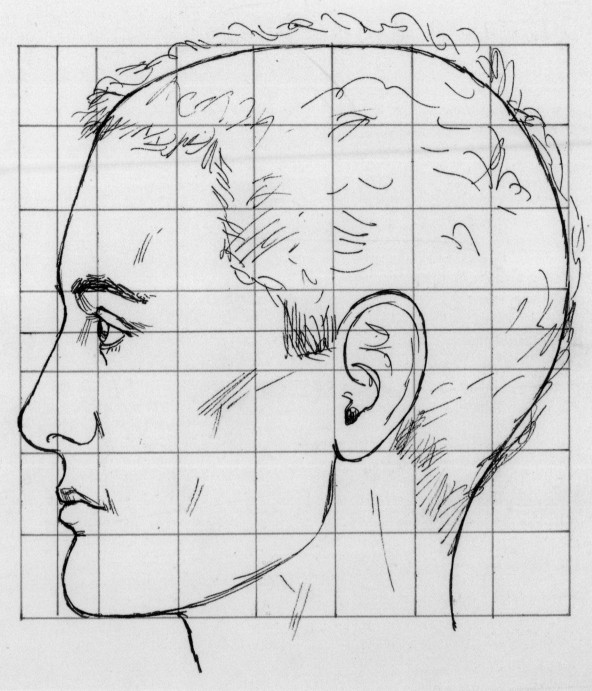

The basic proportion is five units across the width and seven units down the length of the head. Note the central line running the length of the face, passing between the eyes, straight down the nose, past the mouth and then finally the chin.

Even if there is a difference in the size of adult heads, there is no significant difference in proportion. However, the proportions of children's

heads are different from those of adults and they vary from age to age.

Horizontal readings of the profile face:
1. In profile, the head is seven units wide and seven units long, including the nose.

2. The front of the eye is one unit in from the point of the nose.

3. The ear is one unit wide and two units in length. Its front edge is four units from the point of the nose or three units from the back of the head.

4. The nose projects half a unit out from the front of the skull.

Stages of a portrait

The basic shape of the head is the thing you have to start with in your portrait. Make sure that the skull structure is correct and that it sits on the neck in the right way. Take great care at this stage because it makes your task so much easier later on.

1 Next, look at the outline of the hair in relation to the head and sketch this in very simply as one shape. This is more important when the hair is long.

2 Now mark out the positions of the eyes, the nose and the mouth so that they are in the correct relationship to each other, then draw in the shapes of each of the features, getting their shapes right and their size correct in relation to the rest of the head.

3 After all this, you will need to start blocking in the colour, beginning with all the areas of shade on the head. Use a neutral colour and maybe a different colour for the hair.

4 Then block in the rest of the colours, lightest first, followed by the darker ones, until you have gone as dark in tone as you need. Don't use black until right at the end and then only the least you can get away with. It is so strong that you have to be very careful how much you use.

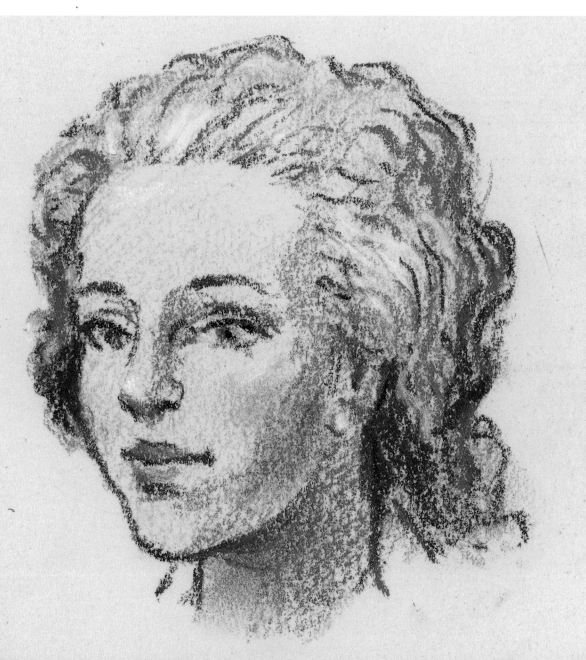

An alternative approach to drawing the head

This alternative approach to drawing the head is one used by many portrait painters, and it works just as well.

1 First, you draw a vertical line to represent the length of the head from the top to the chin and then carefully mark on it the positions of the eyes, which should be halfway down.

2 Draw in – very simply – the shapes of the eyes in their relative positions.

A mark halfway between where the eyes are and the bottom mark, which is the chin, will give you the position of the nose. Draw it in as near as possible to the shape you can see.

The position of the mouth is to be marked in next, and here you will have to be more careful. Do you remember that the lower lip is one seventh of the way from the bottom of the chin? Don't put it halfway between the nose and the chin as it will be too far away from the nose.

3 The next part is very important. First draw in the shapes of the eyes, the mouth and the nose very carefully. Notice how, in the three-quarter view, the far eye and the far side of the mouth are slightly shorter in shape than the near side.

Next draw in the eyebrows. Again the far eyebrow is shorter than the nearer one. When you do the nose, the shadow side can be put in, too, because that helps to define the character of the nose more clearly. It is worth taking the trouble to get all these shapes right.

The next thing is to put in the ear that you can see from this point of view. Lengthwise, it is situated between the eyebrow at the top and the end of the nose at the bottom. Check the distance between the outside edge of the nearest eye and the front edge of the ear, relating its distance to that of the length of the nose. Then draw in the shape.

4 Now shape the mouth. The half of the mouth on the far side of the face will be shorter than the half on the near side. The centre of the mouth should be immediately below the centre of the nose. Then draw in the point of the chin.

Now complete the whole shape of the head, carefully observing the shapes.

5 Finally, treat all the areas of shading fairly lightly at first and then block in the other colours, starting with the lightest first and ending with the darkest. If you want the face to look brighter, give it a darker background colour.

Expressions

When you begin to draw portraits, you may find after a few minutes of posing that people's faces tend to adopt a fixed stare and often a rather bored expression. This is why, in previous times, professional portrait painters used to employ musicians to keep their sitters amused, so that they would not find the business too tedious. Some painters rely on their talent for interesting conversation to keep their sitters lively, but you can see how that might be difficult. So, one thing you can do is to get your sitters to try out various expressions, in order to keep them awake and enjoying the experience of sitting for their portrait.

Facial expressions may be a bit difficult to keep for any length of time, but it is worth trying to get a few down on paper for your own enjoyment, and in order to learn from them.

Here I show a range of basic expressions:

The first is laughter or happiness – some people seem to find it quite easy to keep a big smile on their face long enough for you to draw it.

The next is a smile or a look of serenity which might be what Leonardo da Vinci was trying to capture in the portrait of the *Mona Lisa*.

The next is either angry or grumpy, depending a bit on the intensity.

This one is surprise, although it could become that far-away expression you sometimes fall into when contemplating your next holiday, for instance.

This one should be easy enough – just bore your sitter by telling him feeble jokes or relating in detail how hard it was to park your car.

And the last one is a seductive sort of expression that works best of course if the sitter looks like a filmstar of the more beautiful kind.

Facial features

Here are things to look for when you are making a preliminary study of the sitter's face before you start to draw it. It is these little details that are going to make the difference between the portrait looking like the sitter or not.

2 Then look at the eyebrows. Are they straight or arched? It makes quite a difference to the look of the face.

1 First the eyes, because they are the most dominant part of the human physiognomy. Check whether they are level from corner to corner.

Are they angled so that the outside corners are tilted upwards? Or are they the opposite, tilting downwards at the outside corners?

3 Now look at the mouth. Mouths can be straight along the line of the join of the lips, or they can be curved upwards or downwards at the corners.

4 Not only that, the lips can be thick or thin and, again, this will affect the look of the face.

5 Ears are less noticeable unless they stick out very obviously but, as you can see here with our very small collection, ears do vary quite a bit.

6 Then there is the hairline. This can vary too, but the most obvious feature is whether it forms an even line or a wavy one; and a widow's peak is the most distinctive form of all.

7 When it comes to noses, you can see an amazing variety of shapes and sizes. Look carefully and draw well.

Poses, or how to place your sitter

There's an infinite variety of poses that can be adopted for portraits, but eventually you have to rely on your sitter being able to adopt the position that you feel would be the best. Here I suggest a few poses that might be used, but you will no doubt find many others.

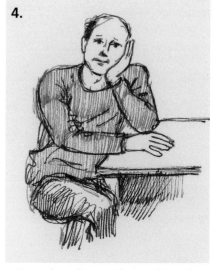

1. The first is the most straightforward – someone sitting upright in a chair directly facing you. It's not very imaginative but may be used to show an uncompromising attitude, which might suit certain sitters.

2. The second is the relaxed pose of someone lying across a sofa – a good horizontal shape that can look both elegant and casual.

3. The third position is difficult to obtain, because you have to be above the sitter and it relies on you having a higher level to work from. However, it is quite distinctive and so could create a lot of interest.

4. Next I show the sort of natural pose that anyone might take up, and these kind of positions do give a natural quality to the portrait.

5.

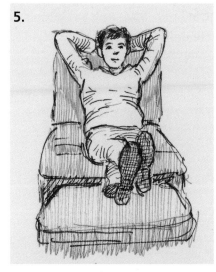

5. The fifth one is much the easiest pose for the sitter to adopt, as long as you don't expect them to keep their arms above their head for too long.

6.

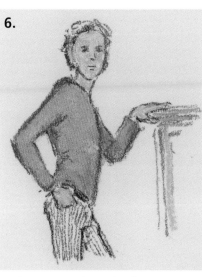

6. This pose is rather stylized, reminiscent of eighteenth- or nineteenth-century portraits of aristocratic figures.

7.

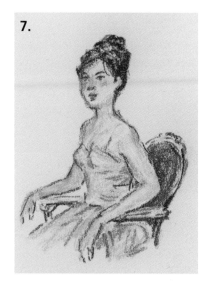

7. This example shows one of the most natural positions for a portrait, where the sitter is dressed in their best clothes and enthroned in a chair – a sort of party piece.

8 A.

8 B.

8 C.

8 a, b and c. You might consider whether you want a rich decorative element to your portrait or, conversely, a very plain, unadorned image. This will depend on your sitter, and you have to try to match the character of their personality with the way you portray them (a). You might decide that you need a little drama in the pose of the sitter, and here I show one in which the subject of the portrait is reflected in a mirror, standing by a mantelpiece, as in James McNeill Whistler's Symphony in White, No. 2: The Little White Girl (b). Or you might want to refer to the particular abilities of your sitter, as in this example, based on the portrait of Charles Dickens at his desk (c).

Materiality

Since most, if not all, of your sitters will be clothed, you need to be able to draw fabrics convincingly. First, here are three pieces of cloth made from natural fibres. It is not always easy to tell the substance of a material from a drawing, but you can give the viewer a lot of information by the way that you treat the texture and shape.

A major clue is that silk is so soft that it never forms harsh or ugly folds. In fact, it always folds so nicely that even if it does not have the characteristic silky sheen, it is usually unmistakable.

With cotton, the look is smoother, with neither the surface reflection of silk nor the heavier texture of wool. It can also be starched and folded to a sharpness that neither wool nor silk can emulate. When cotton fabric is worn and crumpled, it shows much more than the other two.

The quality of wool is similar in some ways but it is a much more dense material. The folds tend to be more generous and thicker, and the texture is often chunkier.

Soft fabrics will drape over the shape of the body, while fabrics with more substance have a stronger form of their own.

Here is someone in one of those draped forms of clothing that people wore when garments resembled – to our eyes – nothing more complex than a sheet. This is like a Roman toga, which winds around the body and fits where it touches.

The second figure is from a later date, although the artist who drew her intended to represent a person from the Classical era. Nevertheless, we notice immediately that the top of the costume is shaped, and it has a voluminous skirt that doesn't appear to be made from the same fabric. So, we would be correct in dating it well after the pure, draped forms of the Classical period and, if our costume history is good enough, we might guess at the Renaissance, which would be right.

Step by step portrait

Before you start the portrait, you will need certain information about, and familiarity with, your sitter. When you first contact them, take a camera and your sketchbook with you, in order to make a record of their face.

1 First, take several photographs of them from as many different angles as you think fit. I usually take a full face shot, a three-quarter left side, a three-quarter right side and then at least one profile. You will also need pictures of them smiling and unsmiling. This should give you quite a lot of information.

2 You should do at least two preliminary drawings from different angles. If you can do more than two that is all to the good.

3 Now you have to make a decision about how you want your model to pose. Your sitter, of course, may have strong ideas themselves but don't hesitate to tell them what you think will work best. In these examples, I've placed the same girl in quite different poses (here, in a formal pose, and in a more relaxed pose over the page).

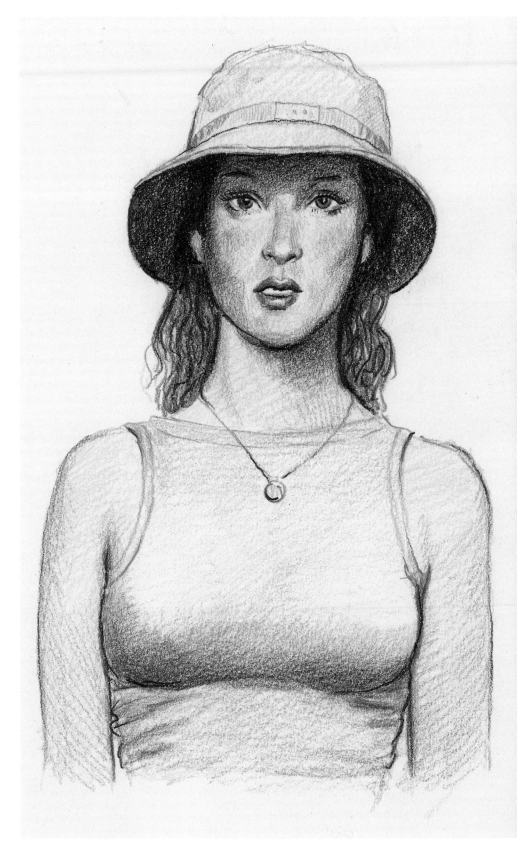

Step by step portrait
continued

4 People often don't know how they want to appear until you suggest something. Have confidence in your own vision, but naturally the sitter has the last word, particularly if they have commissioned you and are paying for the portrait.

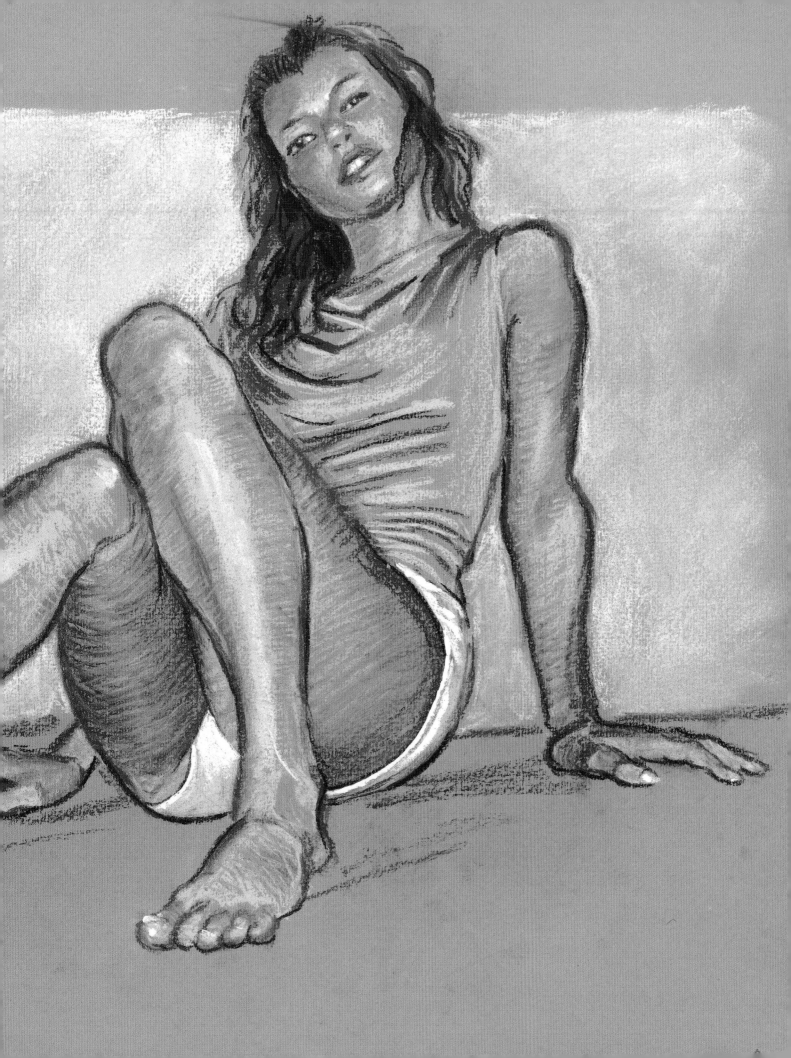

Index